IMAGES
of America

NEW YORK STATE'S
COVERED BRIDGES

On the Cover: The Hyde Hall Bridge is located in Glimmerglass State Park and is the oldest existing covered bridge in the United States. Originally built as part of a roadway to the Hyde Hall estate, this quaint covered bridge still stands where it was originally constructed in 1825. It was listed in the State and National Registers of Historic Places on December 17, 1998. It is one of three covered bridges in New York State with horizontal siding. (Courtesy of the New York State Historical Association Library.)

IMAGES of America
NEW YORK STATE'S COVERED BRIDGES

Bob and Trish Kane

Copyright © 2014 by Bob and Trish Kane
ISBN 978-1-4671-2191-0

Published by Arcadia Publishing
Charleston, South Carolina

Printed in the United States of America

Library of Congress Control Number: 2013953785

For all general information, please contact Arcadia Publishing:
Telephone 843-853-2070
Fax 843-853-0044
E-mail sales@arcadiapublishing.com
For customer service and orders:
Toll-Free 1-888-313-2665

Visit us on the Internet at www.arcadiapublishing.com

*This book is dedicated to our dearly departed friend,
Richard T. Donovan (1928–2004),
also known as Mr. Covered Bridge Extraordinaire.*

Contents

Acknowledgments		6
Introduction		7
1.	Albany, Broome, and Delaware Counties	9
2.	Essex, Fulton, Herkimer, Jefferson, and Lewis Counties	25
3.	Madison, Oneida, and Otsego Counties	37
4.	Rensselaer/Washington, Saratoga, and Suffolk Counties	43
5.	Sullivan and Tompkins Counties	51
6.	Ulster County	67
7.	Washington County	81
8.	Covered Spans of Yesteryear	91
About the Theodore Burr Covered Bridge Resource Center		127

ACKNOWLEDGMENTS

We wish to thank all our covered bridge friends we have met over the years for their words of encouragement in publishing this book. We are deeply indebted to the National Society for the Preservation of Covered Bridges for use of their New York photographs.

Unless otherwise noted, all photographs are from the National Society for the Preservation of Covered Bridges (NSPCB), Richard Sanders Allen Collection.

Also, special thanks to the following individuals who allowed us to use materials from their websites, articles, publications, books, or other media: Robert McIntosh, for permitting us to use material from his book *The Covered Bridges of Washington County, New York*, and Raymond Smith, former program analyst for the New York State Office of Parks, Recreation, and Historic Preservation, for use of excerpts from his paper "Overview of the History of New York's Covered Bridges."

To the following town historians for their submissions of histories on their various towns and covered bridges: Priscilla L. Edwards, Edinburg town historian (Copeland Bridge and the Town of Edinburg); Sharron Hewston, Town of Jay historian and genealogist (Jay Bridge and the Town of Jay); Carol Smythe, Neversink town historian (Halls Mill Bridge and the Town of Neversink); the Catskill Center for Conservation and Development in Arkville, New York, for permitting us to use material from *Timbers of Time: The Existing Covered Bridges of Ulster County, New York*, by Patricia Bartels Miller; Bill Caswell, president of the National Society for the Preservation of Covered Bridges (NSPCB), for his endless hours of scanning photographs and proofreading; Joseph Conwill (NSPCB), for sharing his photographs, proofreading, and making wonderful suggestions for this book; C. Gary Beckstead of Adams, New York, for use of his photographs; Tina Conn of Malvern, Pennsylvania, for allowing us to use photographs from the collection of her late husband, George; Marcia Bailey of Rexford, New York, for allowing us to use photographs from the collection of her late husband, Dick; the Theodore Burr Covered Bridge Resource Center (TBCBRC) in Oxford, New York, for use of their photographic and research materials; and, lastly, all the New York State covered bridge owners who so graciously shared information with us.

INTRODUCTION

The Empire State has a wealth of both natural and man-made wonders; covered bridges fall into the man-made category. They are tangible links with our past and help provide us with a sense of identity and stability. Tucked away in small, country towns throughout New York State, covered bridges stand as picturesque reminders of a quieter way of life. They inspire memories of a simpler time, when Americans lived on family farms and in small close-knit communities.

To a relatively small community of enthusiasts, covered bridges should be preserved at all costs. To tourists, they are rarities worth braving old horse-and-buggy roads to find. To historians, civil engineers, bridge buffs, and others who enjoy a nostalgic look at the United States, they are artifacts of unique craftsmanship. They stand as monuments to builders who had the vision and the ability to design and construct these wooden masterpieces.

It has become increasingly difficult to find covered bridges, but less than 50 years ago, travelers were apt to find dozens in small towns, at crossings from Maine to Mississippi, and as far west as Oregon, California, and even Alaska.

Most people associate New England with covered bridges, and New York State was, historically, abundant with these landmarks. Today, the number of covered bridges in New York has dwindled from more than 300 to a mere 32. In an effort to help preserve all remaining New York State covered bridges, a concentrated effort began in 1997 to include as many qualified bridges as possible in the New York State and National Registers of Historic Places. Of the 32 covered bridges in New York, a total of 17 have now achieved this recognition.

During the Federal period, inventor Theodore Burr (1771–1822) designed a highly successful long-span bridge form that combined the structural advantages of a simple timber truss with a relieving arch. Burr patented his timber truss design in 1817. His first major successful bridge was a four-span structure erected across the Hudson River at Waterford, New York, in 1804. Built of hand-hewn pine structural members, the Waterford Bridge was sheathed with pine plank siding and covered by a shingled roof. Burr's bridge stood for more than a century; it was destroyed by fire in 1909. The Burr arch truss is represented in New York by two extant historic bridges currently listed in the state and national registers: Hyde Hall Bridge (1825) in Otsego County and Perrine's Bridge (1844) in Ulster County. The last remaining structure built by Burr is his former home in Chenango County, which is now the Oxford Memorial Library and the home of the Theodore Burr Covered Bridge Resource Center. This center is dedicated to preserving the history of covered bridges and is the first of its kind.

A successful truss design nearly contemporary with the Burr truss was the Town lattice truss, patented in 1820 by the versatile builder/architect Ithiel Town (1784–1844). Consisting of a horizontal top and bottom chord connected by a web of closely spaced, alternating diagonal timbers, the Town lattice truss included no vertical members; the required stiffness was achieved by connecting the intersecting diagonals with wood pins. Carried on piers placed at intervals, bridges incorporating the Town lattice truss could span considerable distances. The inherent strength of the Town lattice truss, coupled with its ease of construction, made it a popular design for highway and early railroad bridges until the post–Civil War era. Listed in the state and national registers in 1972, the covered bridges at Eagleville (1858) and Shushan (1858) in Washington County are notable examples of the Town lattice truss form. Other notable examples listed in the registers include Fitch's (1870) and Lower Shavertown (1877) bridges in Delaware County, Beaverkill (1865) in Sullivan County, Newfield (1853) in Tompkins County, and Mill Brook Bridge (1902) and Ashokan-Turnwood (1885) in Ulster County.

During the 1830s, Col. Stephen H. Long (1784–1864), of the US Army Corps of Topographical Engineers, perfected a rigid timber truss form that incorporated panels consisting of intersecting

diagonals and counters. Long's initial patented 1830 design for an "assisted truss" included a redundant king post relieving truss above center panel points (where the greatest flex would occur). With practical experience, Long refined his design to eliminate its "overbuilt" characteristics, receiving additional patents in 1836, 1839, 1847, and 1858. The former Blenheim Bridge (1855) in Schoharie County (a National Historic Landmark and a National Civil Engineering Landmark) and the Hamden (1859) and Downsville (1854, with added queen post) bridges in Delaware County are/were all notable examples of the Long truss design.

The final major timber truss design to achieve widespread popularity during the late 19th century was first patented in 1840 by William Howe (1803–1852). The Howe truss consisted of horizontal timber top and bottom chords and diagonal wood compression members combined with vertical tension members made of wrought iron. The ends of the iron tension rods were threaded and secured to iron shoes at the panel points of the web. The inherent properties of wood and iron as construction materials were effectively used in Howe's truss; this hybrid truss became the most widely constructed, standard American timber bridge form of the 19th century. The Jay Bridge (1857) in Essex County and the Rexleigh (1874) and Buskirk (1857) covered bridges in Washington County are Howe truss structures listed in the state and national registers.

As of August 2011, New York State could lay claim to two very prestigious covered bridges. First is the Hyde Hall covered bridge, which was built in 1825 and proudly stands in Otsego County's Glimmerglass State Park near Cooperstown. It is the oldest existing covered bridge in the United States and displays a true Burr truss.

Our second prestigious covered bridge was the Blenheim Bridge. It was the longest single-span covered bridge in the world, measuring 228 feet in length, and was located in Schoharie County in the small village of North Blenheim. It was one of only six double-barrel covered bridges still standing in the United States. The Blenheim featured the rarely used Long truss. Blenheim's builder, Nichols Powers, combined the Long truss with an arch. Unfortunately, the Blenheim Bridge was washed away by the rising floodwaters of the Schoharie Creek when Tropical Storm Irene struck New York on August 28, 2011.

Today, covered bridges continue to be built in New York State. The Munson Bridge, located in Broome County, was built in 1991. It is New York's shortest covered bridge and is one of only two queen post truss bridges in existence in the state. Queen post trusses were used to support shorter bridge spans.

The state's newest covered bridge, built in 2005, is the Erwin Park Covered Bridge in the village of Boonville in Oneida County. It displays a Town lattice truss design, which can be seen in 12 of New York's covered bridges.

Geographically, Delaware County has the most covered bridges (a total of six). Three of these bridges (Fitch's, Hamden, and Downsville) are owned and maintained by the county, while the remaining three are owned by private individuals or groups.

As you turn the pages of this book, we hope you enjoy a journey back in time as you discover the covered bridges of the Empire State.

One
ALBANY, BROOME, AND DELAWARE COUNTIES

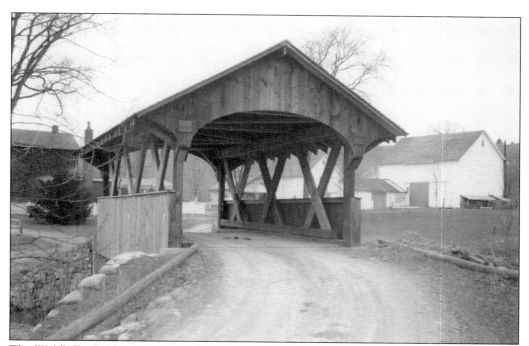

The Waldbillig Bridge (private) is the only covered bridge still standing in Albany County. The single-span structure was built in 1955 by Gerald and Michael Waldbillig and measures 30 feet in length. It is believed to incorporate a Warren-style truss design. The Warren truss is very rare, and this bridge may be one of only two trusses in New York State thought to be built in that style.

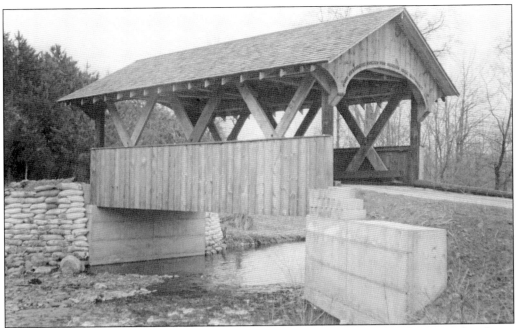

On the Waldbillig Bridge, in raised letters across the portal facing the farmhouse, is the phrase "*Quid retribuam Domino pro omnibus quae retribuit mihi.*" Translated from Latin, it means: "How shall I repay the Lord for all that he has given to me?"

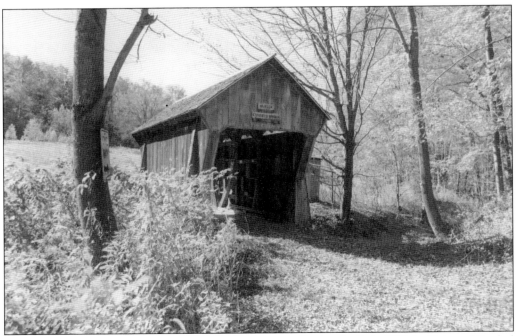

Located on private property near Vestal is the Munson Bridge, built in 1991 by Bob and Rachel Munson. The single-span bridge is 22 feet long and crosses Munson Creek. (Photograph by Trish Kane.)

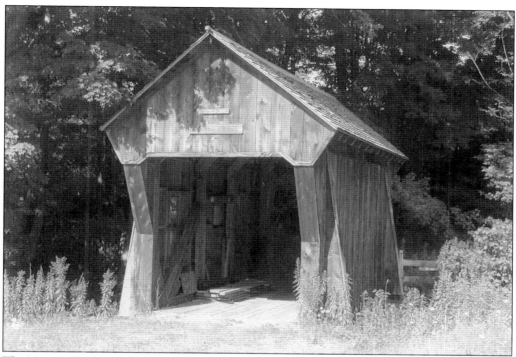

The Munson Bridge is New York's shortest covered bridge and one of two queen post truss covered bridges in the state. A queen post is a type of truss that has two diagonal posts that rise up from a chord at the bottom to support the bridge. The posts are connected by a horizontal support. These trusses are used throughout the world in both interior and exterior residential architecture, as well as in public buildings and bridges. (Above, photograph by Jim Smedley; below, photograph by Trish Kane.)

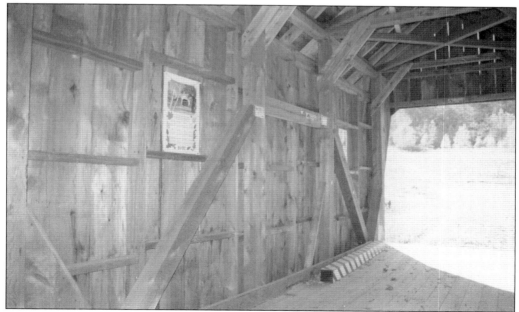

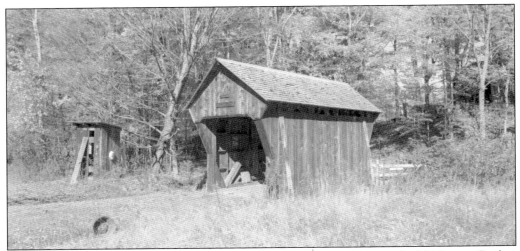

Robert and Rachel Munson worked faithfully for a few hours each day to build Munson Bridge, using all rough hemlock lumber and cedar shingles for the roof. It took 3,732 board feet of hemlock, 98 pounds of nails, 16 bundles of Canadian cedar shingles, and 10 yards of cement to build the bridge, which the Munsons worked on for a total of 257 hours. It was completed in September 1991 and dedicated on October 13, 1991. (Photograph by Trish Kane.)

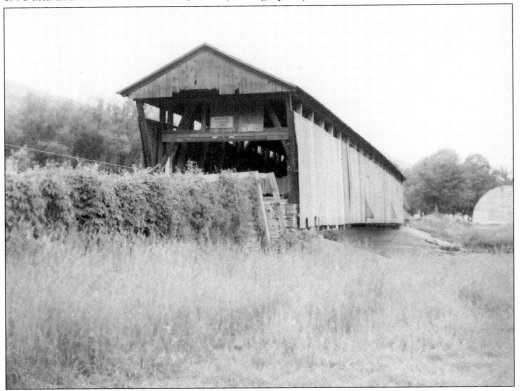

Robert Murray and the Town of Colchester signed a contract for Murray to construct the Downsville Bridge for the sum of $1,700. This bridge is one of three covered crossings that still carry traffic across branches of the Delaware River. (Photograph by John Bennis; TBCBRC.)

Built by Robert Murray in 1854, the 174-foot-long, single-span Downsville Bridge incorporates the Long truss design patented in 1830 by Col. Stephen H. Long of Hopkinton, New Hampshire, with an added queen post truss. This truss design is rare in northeastern covered bridges. This is New York's only covered bridge that displays a Long truss with an additional queen post truss.

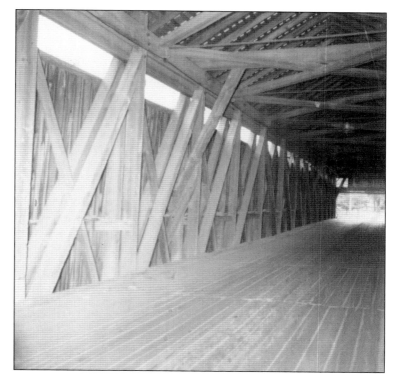

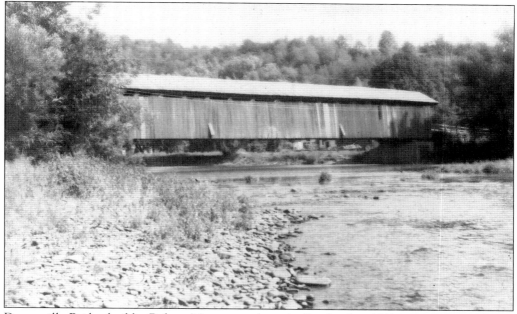

Downsville Bridge builder Robert Murray was born in Scotland in 1814 and immigrated with his parents at age nine. Folklore has it that at the time the Hamden and DeLancey Bridges were being built, Murray would walk to his bridge sites early on Monday morning, board during the week, and hike home again on Saturday night. He reportedly always went barefoot, carrying his shoes to save wear on them. (Photograph by John Bennis; TBCBRC.)

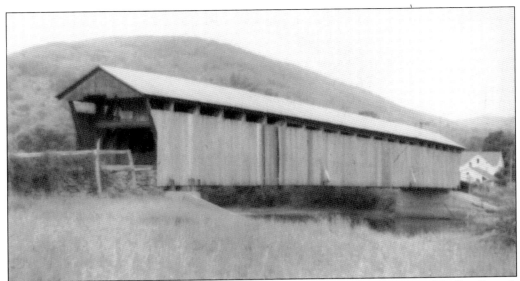

Throughout the years, Downsville experienced many floods due to the overflowing of the East Branch of the Delaware River. Robert Murray may have anticipated this happening and built the Downsville Bridge high above the river. Throughout the years, the Delaware County highway department tried to close the old bridge to traffic and reserve it for use as a footbridge, but Downsville residents were insistent the bridge continue to be used for the purpose it was designed for. The Downsville Bridge is the oldest of the six covered bridges in Delaware County. It is one of three bridges owned and maintained by Delaware County; the other three bridges are privately owned. In 1998, it was rehabilitated at a cost of $975,000. (Both, photograph by John Bennis; TBCBRC.)

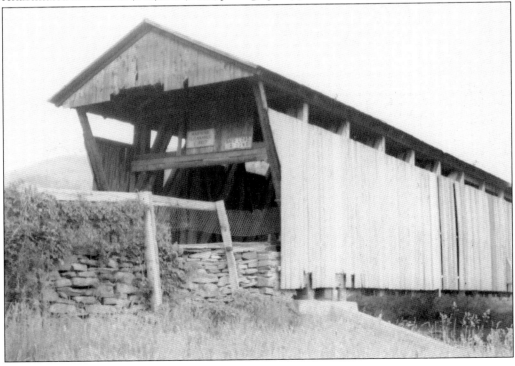

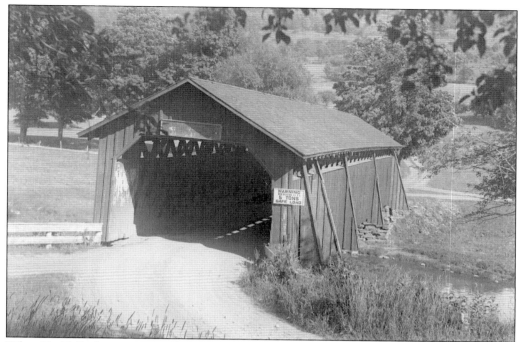

When Fitch's Bridge was originally erected in Delhi in 1870, it was built to carry traffic on Kingston Street across the West Branch of the Delaware River. Around 1885, when a new Kingston Street bridge was required, David Wright and a few frugal town officials dismantled this lattice truss bridge, carefully marking the timbers, and transported it by wagon three miles farther upstream. Fitch's Bridge, built by James Frazier and James Warren, is a 113-foot-long, single-span structure that incorporates the Town lattice truss design patented in 1820 by Ithiel Town of New Haven, Connecticut. The total cost to build this bridge in 1870 was $1,900; in 2001, rehabilitation costs totaled $424,339.

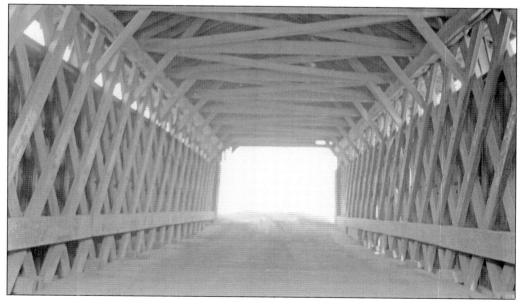

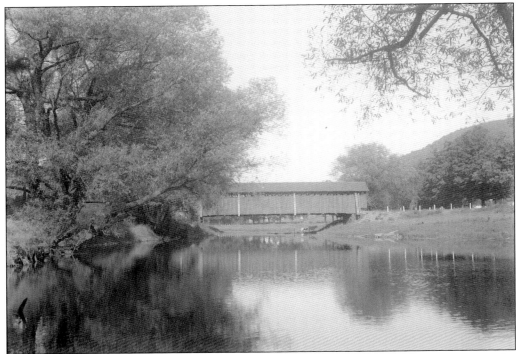

When Fitch's Bridge had to be relocated in 1885, David Wright found it easier to reerect the bridge to face in the opposite direction from which it stood in Delhi. As a result, all the timbers marked east are on the west side and vice versa. These markings are still visible on the bridge today. During the 1885 move, Fitch's Bridge was also shortened from the length it had been at its original site. At the new location, the bridge opened into a steep uphill grade on the north end. To meet this grade, the plank floor inside sloped upwards beginning several feet from the north end. This reduced the clearance on the north end, so in the 1980s, the entire bridge was raised and the floor was reframed to make it straight from end to end.

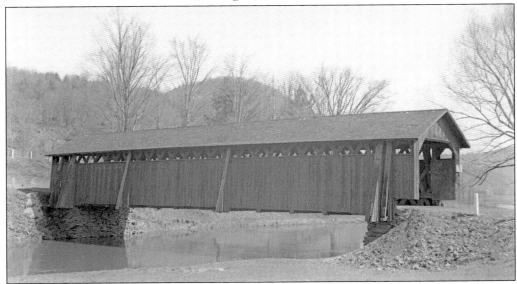

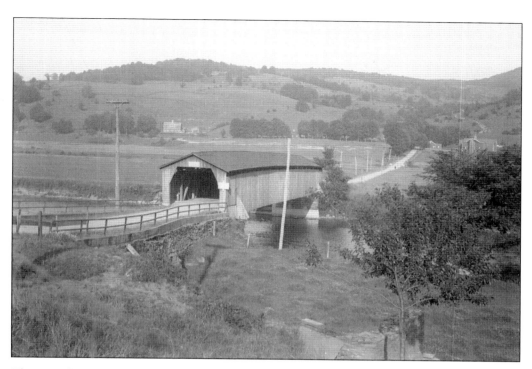

The Hamden Bridge, built by Robert Murray in 1859, is owned and maintained by Delaware County. The 128-foot-long, single-span bridge incorporates the Long truss design patented in 1830 by Col. Stephen H. Long. It is New York's only covered bridge that incorporates a pure Long truss design unassisted by arch or queen post truss. (Below, photograph by Trish Kane.)

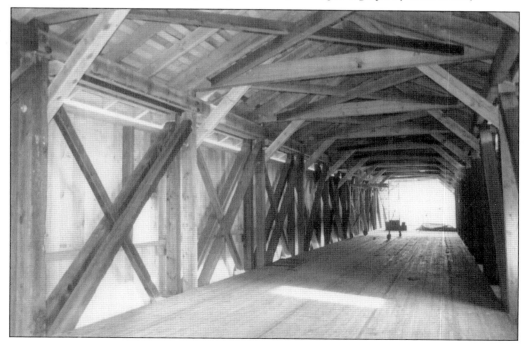

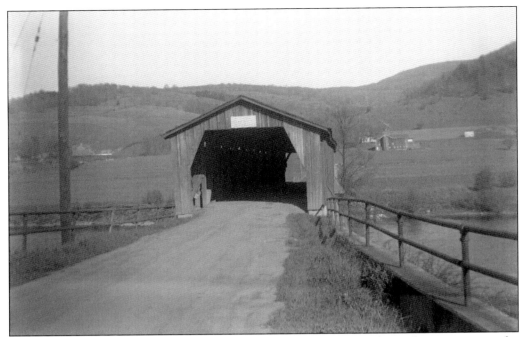

On April 27, 1859, Robert Murray signed a contract with the Town of Hamden to construct the Hamden Bridge for the sum of $1,000. Rehabilitation cost in 2001 was $708,000. When it was originally constructed, the Hamden Bridge was a single span, but in the 1940s, a center support was added for additional strength. During the early 1960s, the timbers and overhead bracing still displayed advertising for Kendall's Spavin Cure, Herrick's Pills, and Ayer's Cherry Pectoral.

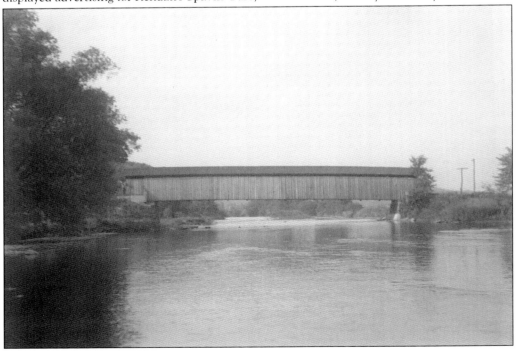

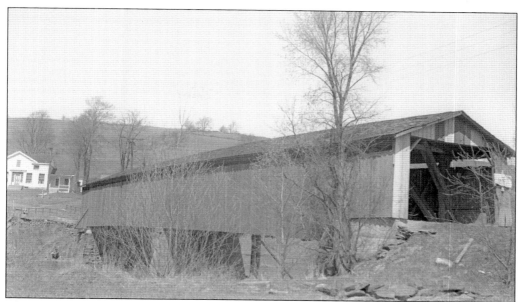

The county repaired a lean in the Hamden Bridge in 1966 by adding two large buttresses on each side. Buttresses were often added to bridges for additional support. That same year, the bridge received its first coat of red paint. In 1967, the portals, the opening at the entrance to the bridge, had a diagonal appearance, but sometime during the late 1970s or early 1980s, the portals were squared.

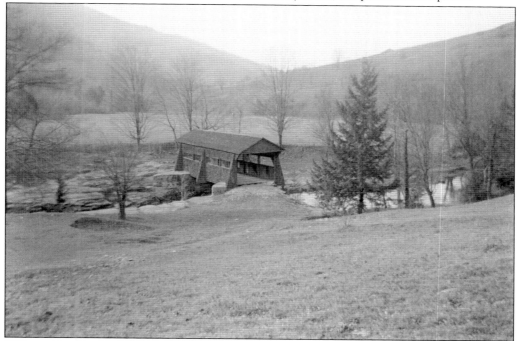

William Mead built the Tuscarora Club Bridge in 1870 in Dunraven, New York. This 38-foot-long, single-span structure incorporated a queen post truss and remained as such until it was sold in 1935 and moved to its current location on private property owned by the Tuscarora Club. During the move, it was shortened and converted to a king post truss.

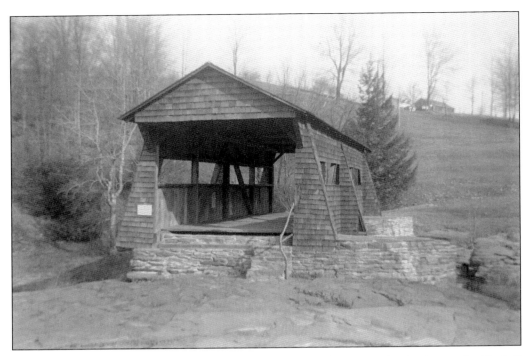

The Tuscarora Club Bridge is very similar in dimensions and design to other bridges in the Catskill region, most of which feature buttresses. The Tuscarora Club Bridge has three buttresses on each side. Another interesting feature of this bridge is that it is completely shingled; this is the only covered bridge in New York State that incorporates cedar shingles as siding.

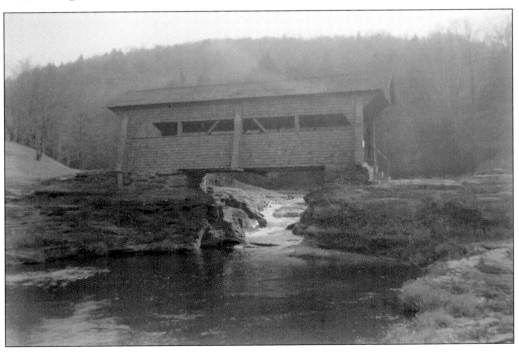

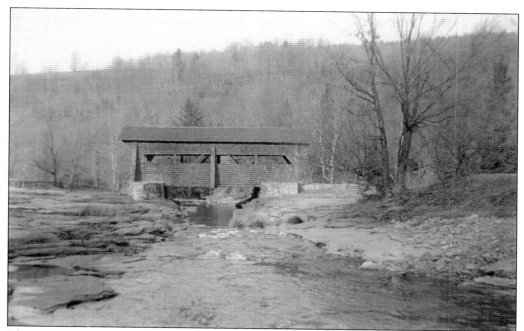

The Tuscarora Club Bridge was destroyed by floodwaters from Tropical Storm Irene on August 28, 2011. It was rebuilt in 2012 by Arnold Graton and Associates using an authentic king post truss. This is a private bridge, and visitors are required to obtain permission to visit it.

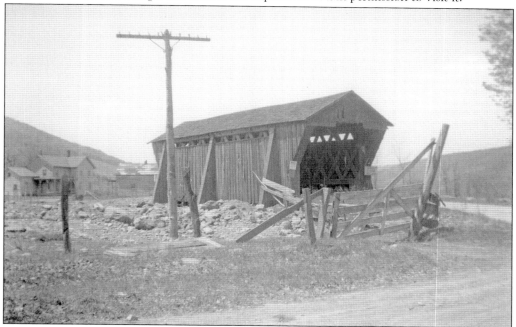

Anson Jenkins and August Neidig built the Lower Shavertown Bridge in 1877. This 32-foot-long, single-span structure incorporates the Town lattice truss design. Like the Tuscarora Club Bridge and many bridges in the Catskill region, it features buttresses. Today, in its new location, the Lower Shavertown Bridge has only two such buttresses on each side.

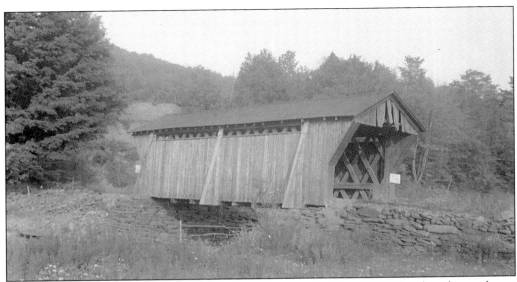

The little Lower Shavertown Bridge once crossed the mouth of Beech Hill Brook at the southwest perimeter of Shavertown. It was originally known as the Methol Bridge. In 1953, when Carl Campbell, from Roscoe, New York, heard that the Pepacton Reservoir was expected to cover this bridge (along with five small towns), he submitted a $1,000 bid for the structure and won the bid; this has also been referred to as the Campbell Covered Bridge. Moving the bridge had to be planned well, as the bridge had not been used for quite a few years. The roof and flooring were in such poor condition that they could not be reused and were discarded when the bridge was dismantled. The bridge was moved during the late summer of 1954, when water was at its lowest level in Beech Hill Brook.

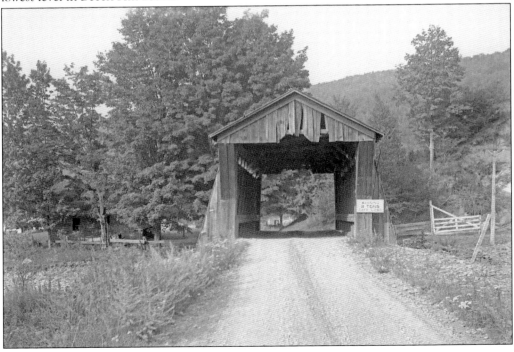

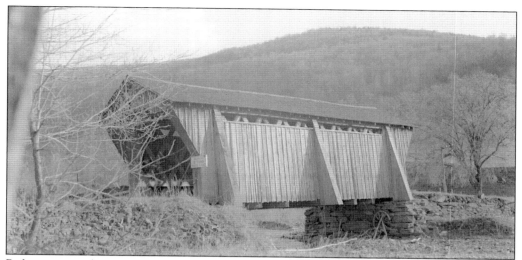

Before moving the Lower Shavertown Bridge in 1954, new owner Carl Campbell had a new floor in place awaiting the arrival of the bridge. At the site, the sides were winched from the truck and left standing on one side of the bridge floor. Keeping constant pressure on the guy wires, workers pried the sides into place. They then squared up the sides, replaced the tie beams and rafters, and finished the roof. Today, this is still a privately owned bridge.

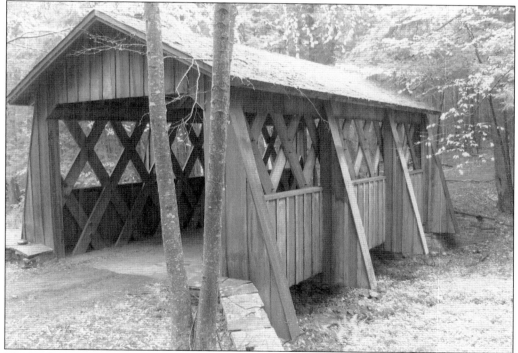

The Erpf estate—which contains this structure, the Erpf Bridge—began in the early 1900s when Dr. Lefkovic, a general practitioner, was staying at Locust Grove during the summer. One day, after a walk, he decided it would make a wonderful place for a home. He bought the first 15 acres and, in 1910, constructed a majestic home. Lefkovic continued to add to his acreage, purchasing adjoining land until he owned 400 acres. (Photograph by Dick Bailey.)

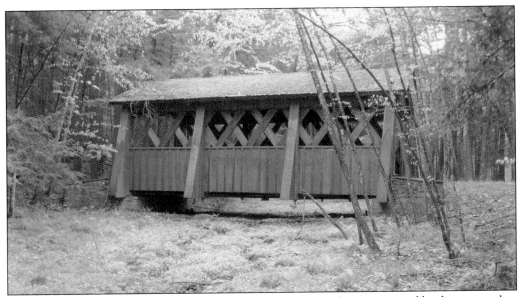

Seager Fairbairn built the Erpf Bridge in 1964. It is a private bridge, maintained by the owner, that carries pedestrian traffic across a pond outlet. This 31-foot-long, single-span structure incorporates the Town lattice truss design. Fairbairn used metal rods saved from the dismantled Vermilyea Place Bridge. He designed and turned his own square-headed trunnels (also known as treenails) and dipped them in a half-and-half mixture of linseed oil and kerosene to help prevent them from decay and bug infestation. The crisscrossed lattice trusses and the gains were bolted only on the tops and bottoms. The exterior is redwood, and the interior is fir. Its abutments are made of Permastone. The total cost to build the Erpf covered bridge was $5,000. (Above, photograph by Dick Bailey; below, photograph by Trish Kane.)

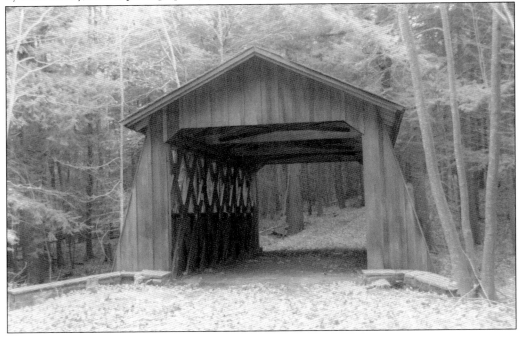

Two
Essex, Fulton, Herkimer, Jefferson, and Lewis Counties

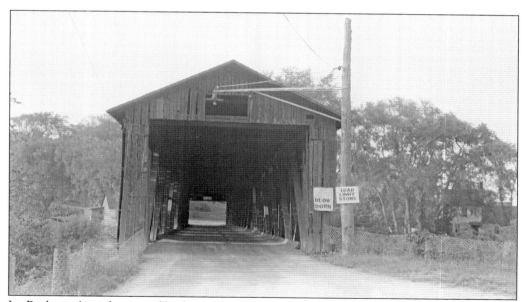

Jay Bridge is the only covered bridge still standing in Essex County. It is owned by the county and carries pedestrian traffic across the East Branch of the Ausable River. The first covered bridge in this location was destroyed by the "great freshet" (flood) of 1856.

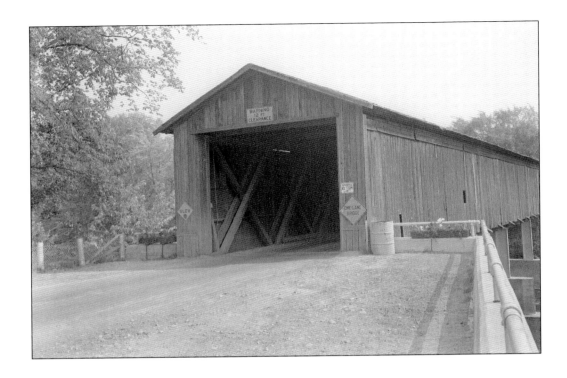

George M. Burt built the present-day Jay Bridge in 1857 for $1,200, but the bridge was not covered until 1858. The 175-foot-long, single-span structure incorporates the Howe truss design patented in 1840 and improved in 1850 by William Howe of Springfield, Massachusetts. This is one of only three Howe truss bridges in New York State. (Above, photograph by Herbert Richter; NSPCB.)

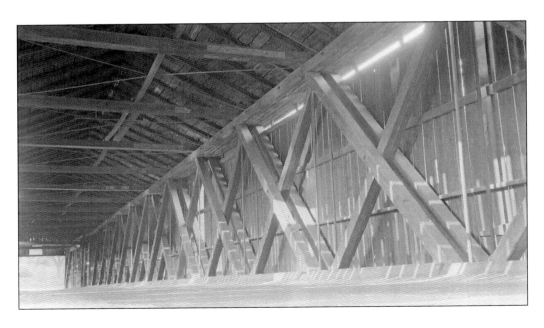

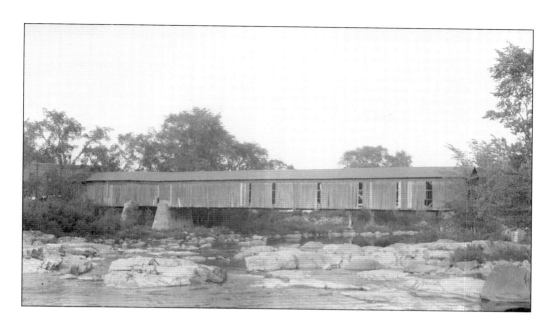

Information gleaned from reliable sources illustrates the history of the first bridge located in the Jay Bridge area. On September 30, 1856, it began to rain, and during the night, a violent thunderstorm produced a torrent. David Heald, who had a cabin at Rainbow Falls, had been working on the dam and told of the cataract he had seen on Mount Colvin—a cataract 2,000 feet high and a mile wide. The dam went out after 10:00 p.m., and the water in the Keene Valley rose almost three feet in 15 minutes. Ten bridges crossing the East Branch were carried downstream (with the exception of two at Keeseville). Among the bridges carried away were the ones within the township of Jay, including the one that preceded the present-day Jay Bridge.

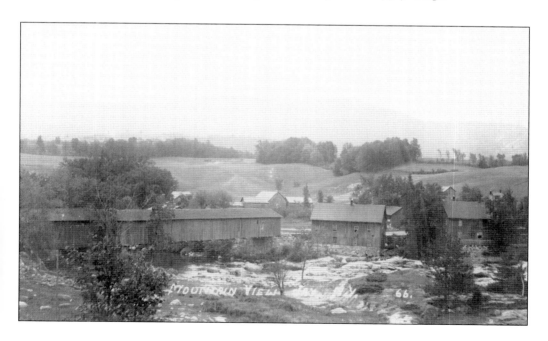

27

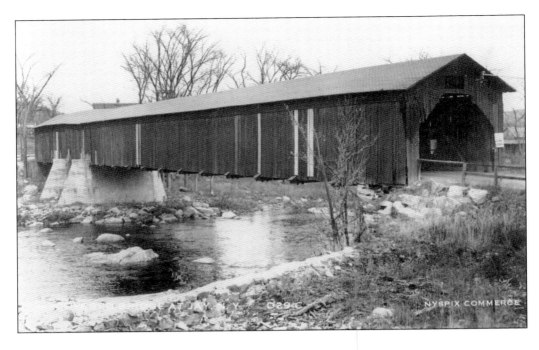

The Jay Bridge had two piers before the three center supports were added sometime after 1910 for additional strength. In the photograph above, the portal still has the angled look. (Below, photograph by John Bennis; TBCBRC.)

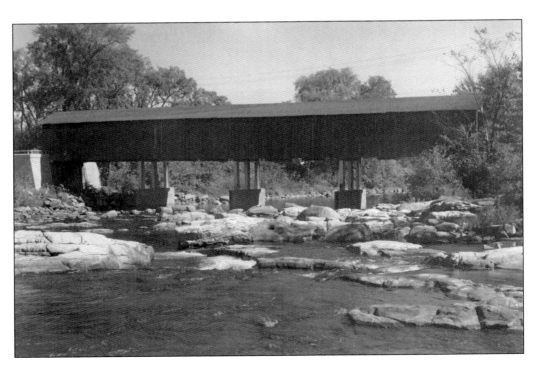

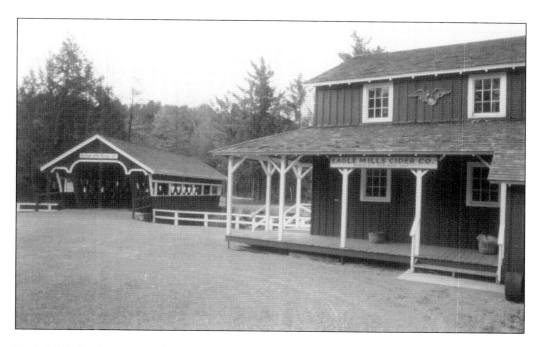

Eagle Mills Bridge is a single span and one of only two covered bridges in the state that has a double walkway attached to the bridge. The waters of the Kennyetto Creek, which flows under the covered bridge, also power the antique waterwheel in the mill located near the bridge. When John Gasner built this bridge in 1967, he used lumber milled at local sawmills from area trees. The large beams underneath were recovered from the dismantling of an old carpet mill in Amsterdam, New York. These beams, now serving as part of the Eagle Mills Bridge, once held the weight of massive carpet looms. (Above, photograph by C. Gary Beckstead; below, photograph by George Conn.)

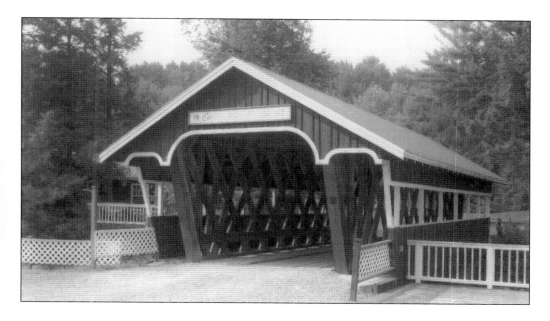

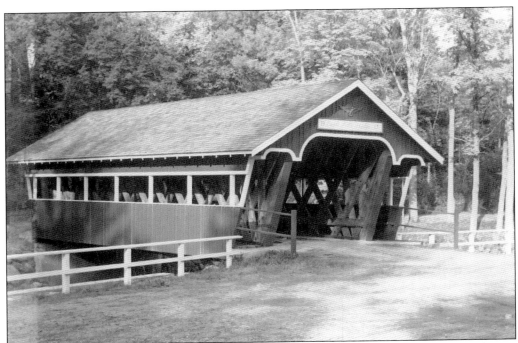

The Eagle Mills Bridge is 45 feet in length and displays a Town truss. It has been the site of many weddings and other events. (Photograph by John Bennis; TBCBRC.)

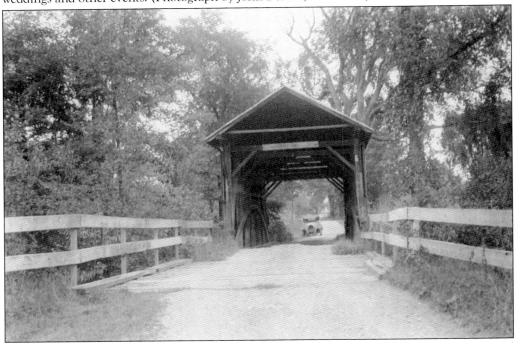

The Salisbury Center Bridge, the only covered bridge still standing in Herkimer County, is owned and maintained by the village of Salisbury Center and carries traffic across Spruce Creek. Spruce Creek once claimed seven covered bridges, all in the town of Salisbury.

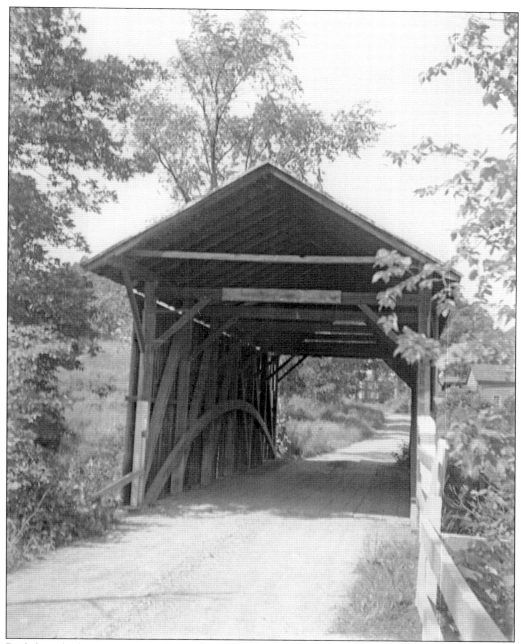

Built by Alvah Hopson in 1875 at a cost of $478, the 50-foot-long, single-span Salisbury Center Bridge incorporates multiple king posts and an added arch. This photograph offers a clear view of the truss.

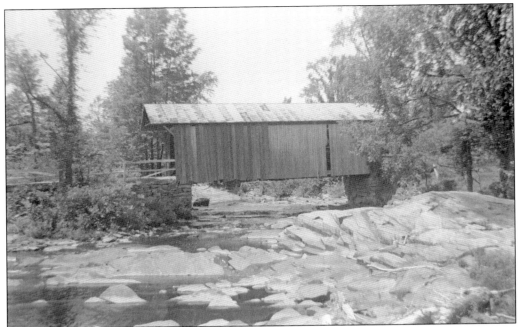

During the 18th century, many settlers came to this hilly countryside from Salisbury, Connecticut, and kept the name of their old hometown. Alvarius Hopson moved his family of six sons and five daughters to Salisbury during that time of population influx. A descendant of Alvarius Hopson, Alvah Hopson, built many covered bridges in Herkimer County. The last bridge he built, the Salisbury Center Bridge, was probably the first prefabricated structure in the area. It is one of five covered bridges in New York State that has a timber approach. Alvah Hopson built this bridge near his home and then dragged it to the Spruce Creek location where it still stands today.

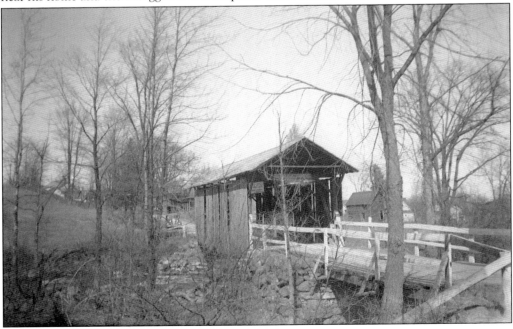

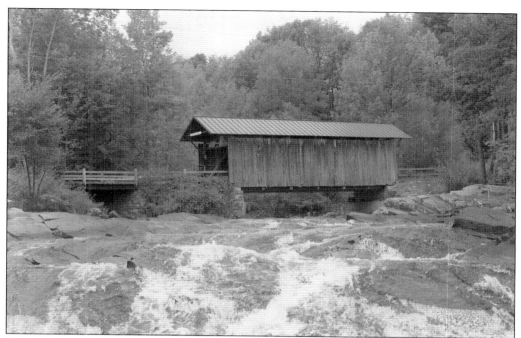

The Salisbury Center Bridge is situated just above McDougal Falls and still spans Spruce Creek. (Photograph by Trish Kane.)

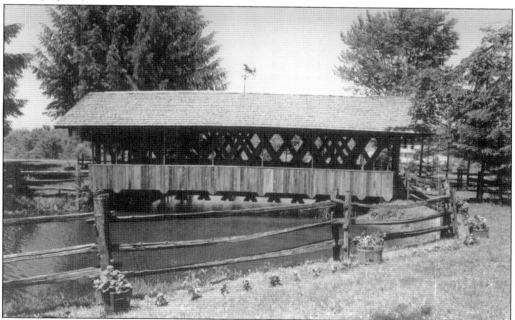

The Frontenac-North Country Bridge is located in the small hamlet of Butterville, near the town of Adams, New York. Although it is privately owned, visitors are welcome. It was built in 1979 by C. Gary Beckstead and measures 42 feet in length. It displays a Town truss and is a single span. This bridge, like the Eagle Mills Bridge, has a double walkway attached to the bridge. (Photograph by C. Gary Beckstead.)

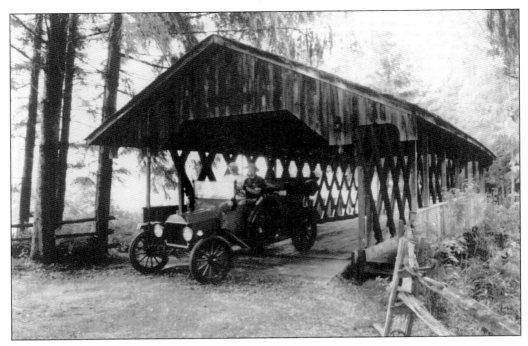

In 2005, the Frontenac-North Country Bridge was visited by Dave Liepelt, president of the Model T Club from Dearborn, Michigan, who drove his 1915 Model T Ford 1,100 miles under its own power on a trip through upstate New York. This bridge has also hosted many meetings of the New York State Covered Bridge Society and served as the backdrop for WWNY-TV Channel 7 News of Watertown, New York. (Both, photograph by C. Gary Beckstead.)

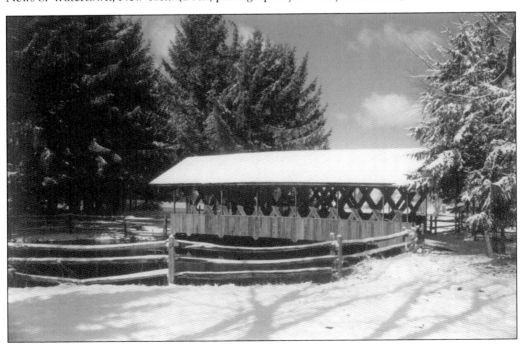

The Rether Covered Bridge, the only existing covered bridge in Lewis County, is maintained by the owner and carries private traffic across an unnamed stream. Built by Roger Rether in 2002, this 25-foot-long, single-span structure incorporates the king post truss design. A king post truss is one of the oldest and simplest truss forms. (Both, photograph by Trish Kane.)

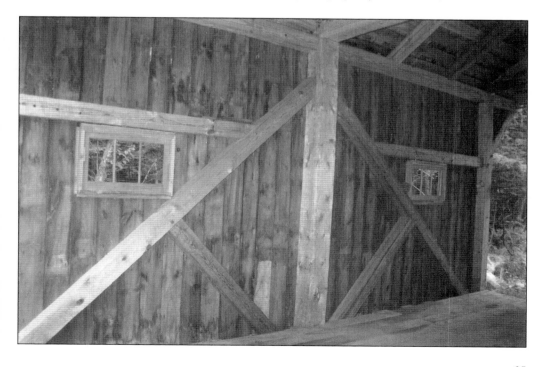

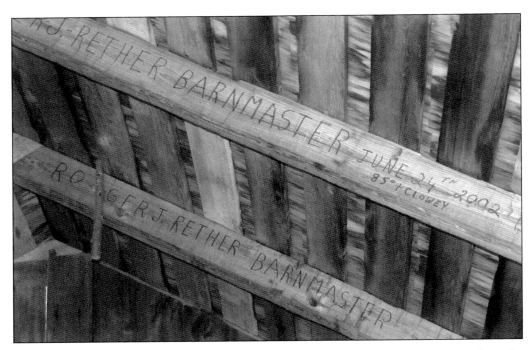

Roger Rether built this bridge to cross a stream, giving him access to his camp on the other side. He was proud of his little bridge and signed his work in the rafters of the bridge. The lovely bridge is probably New York's most difficult bridge to find. It is a private bridge, and it sits secluded in a beautiful section of the woods and requires a short half-mile walk to visit it. (Both, photograph by Trish Kane.)

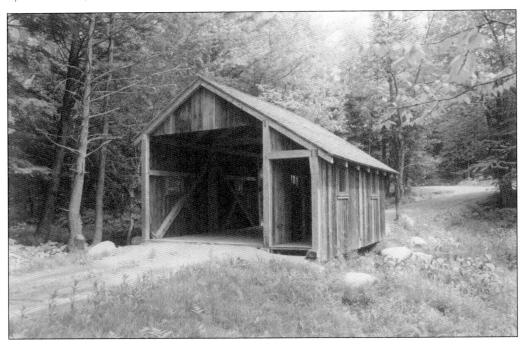

Three
MADISON, ONEIDA, AND OTSEGO COUNTIES

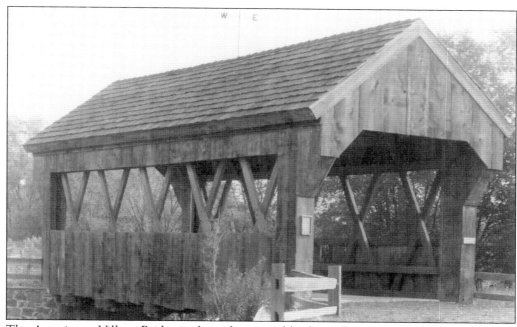

The Americana Village Bridge is the only covered bridge still standing in Madison County. Built by Donald Burch in 1968, this 33-foot-long, single-span structure is thought to incorporate a Warren-style truss design. The Warren truss is very rare, and the Americana Village Bridge may be one of only two trusses in New York State thought to be a Warren style. (Photograph by Noel Rubinton; TBCBRC.)

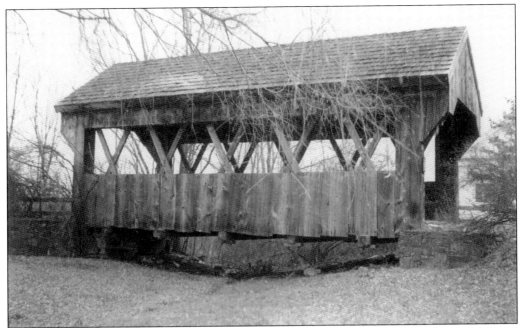

In the early 1960s, the property containing the Americana Village Bridge, as well as a pond and several acres surrounding it, was purchased by the American Management Association, which constructed a conference center on the property. The association also decided to include a historic early American village in the design. As with many early American villages, it included a covered bridge. (Photograph by Trish Kane.)

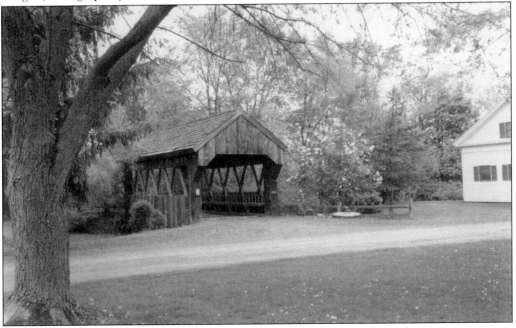

This is how the Americana Village Bridge appears today. Although it is located on private property, visitors are allowed. (Photograph by Trish Kane.)

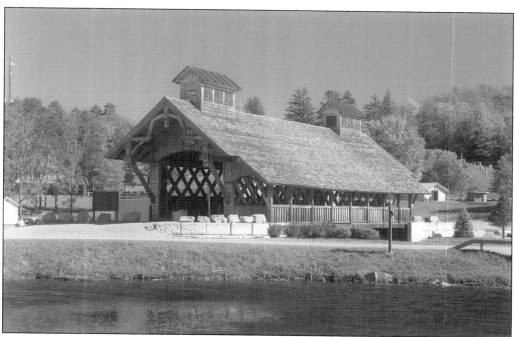

The Erwin Park Bridge, the only covered bridge still standing in Oneida County, is owned and maintained by the Town of Boonville and carries pedestrian, bicycle, and snowmobile traffic across the Black River Canal. Built by Robert Klosner and H.N. Mac Waterman in 2005, the 70-foot-long, single-span structure incorporates the Town lattice truss design. The 12-member Erwin Park Covered Bridge Committee planned and promoted the construction of this covered bridge. The deck is 24 feet wide and accommodates a 14-foot driving area and a 6-foot walkway. (Both, photograph by Trish Kane.)

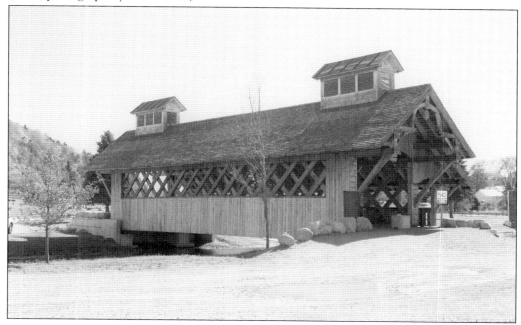

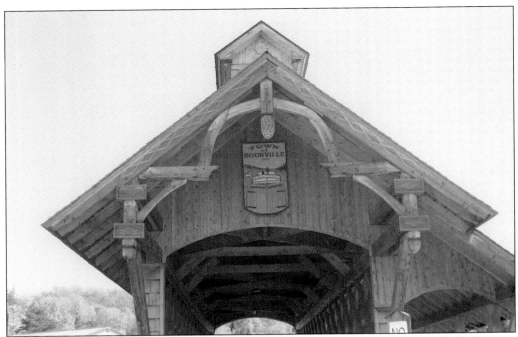

The beautiful carved pinecone displayed just above the sign on the Erwin Park Bridge was carved from the Colorado blue spruce that once stood in another park in Boonville. The tree was approximately 70 years old and 18 inches in diameter. The wood from this tree is also part of the trim over the portals. Two six-foot cupolas sit atop the bridge and feature stained-glass windows at each end. The total construction cost was around $150,000, with construction funded by the New York State Parks Department and a donation of $20,000 from the Iroquois Pipeline Operating Company. (Both, photograph by Trish Kane.)

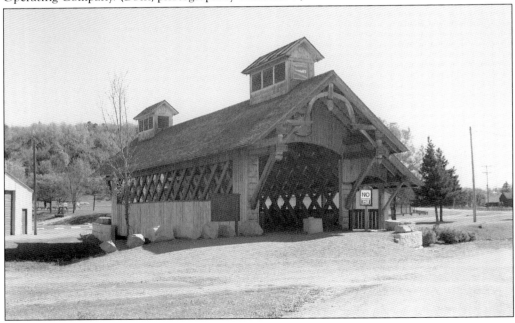

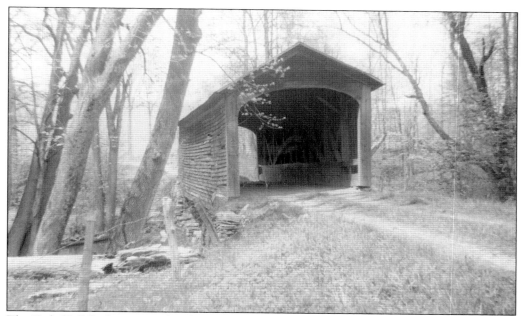

The Hyde Hall Bridge is owned and maintained by the State of New York. Built by Cyrenus Clark, Andrew Alden, and Lorenzo Bates in 1825, this 53-foot-long, single-span structure incorporates the Burr arch design patented in 1817 by Theodore Burr of Torringford, Connecticut. This is one of two authentic Burr arch truss bridges in the state and is located at the northern tip of Otsego Lake in Glimmerglass State Park. The Hyde Hall Bridge is not only the oldest existing covered bridge in New York State, but the oldest in the United States. It was listed in the New York State and National Registers of Historic Places on December 17, 1998.

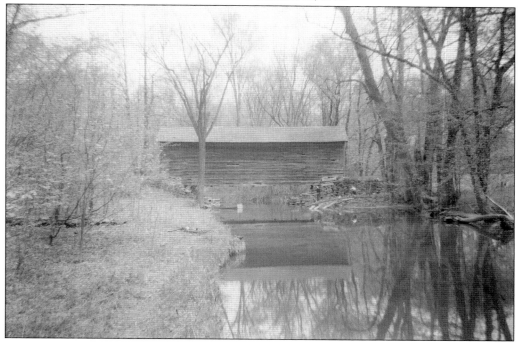

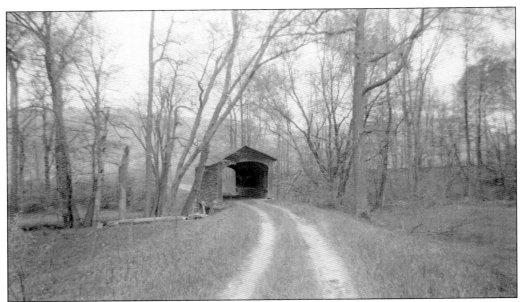

The Hyde Hall Bridge was originally built as a way to cross Shadow Brook and provide traveler's access to the Hyde Hall Mansion. It is one of three covered bridges in New York State with horizontal siding. This bridge was restored in the late 1960s by the New York State Office of Parks, Recreation, and Historic Preservation. The Burr truss design was used in thousands of bridges across the country. Normally, in a Burr arch, the great arches are made sturdy and rigid by framing them together with a multiple king post truss. The Hyde Hall Bridge, however, incorporates an interesting deviation from the patented design and was built with an "X" frame as opposed to the king posts, as was the Philippi Covered Bridge in West Virginia.

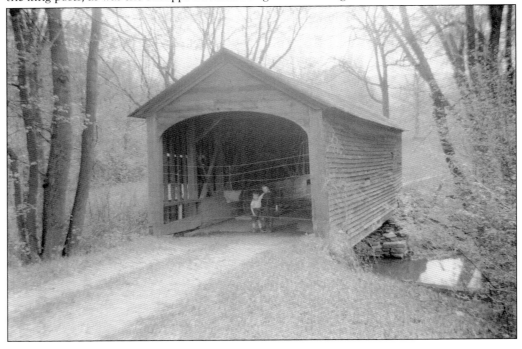

Four
Rensselaer/Washington, Saratoga, and Suffolk Counties

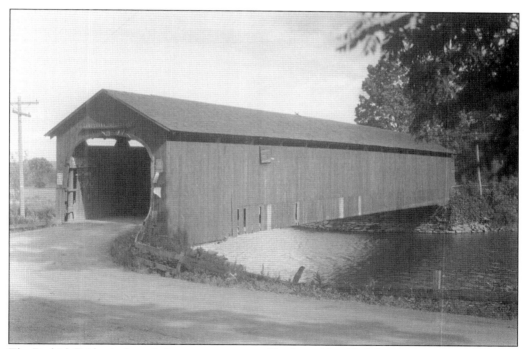

The Buskirk Bridge is the only inter-county covered bridge in New York State; it traverses Rensselaer and Washington Counties. It is owned and maintained by both Rensselaer and Washington Counties and carries traffic across the Hoosic River.

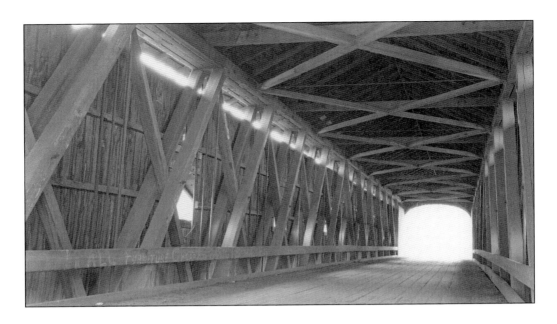

The 158-foot-long, single-span Buskirk Bridge incorporates the Howe truss design. It is one of only three Howe truss bridges in New York State. This bridge was built by Peter Osterhauth, Charles Newman, James Roberts, and Charles Ingalls in 1857. The original construction cost is unknown. It is also unknown how many times traveling across this bridge was interrupted by springtime ice breakups or heavy summer storms, either of which can suddenly turn the Hoosic River into a raging, destructive torrent. (Above, photograph by Henry A. Gibson; NSPCB.)

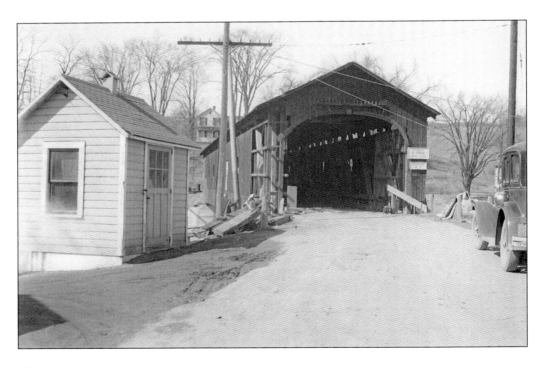

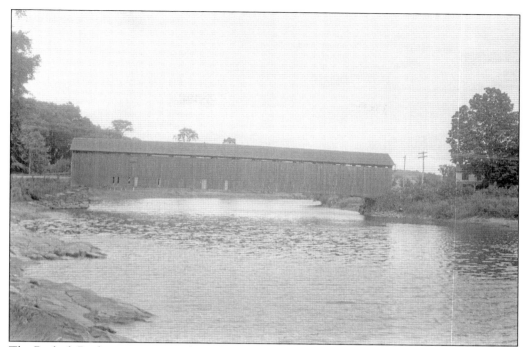

The Buskirk Bridge is at a point where the Hoosic River widens into broad flood plains. In 1804, this location was deemed suitable for the construction of mid-channel piers to support a multiple-span log bridge. A more sophisticated bridge was built in 1812, possibly a single-span open timber truss similar to one constructed by Theodore Burr to cross the Hudson River in 1804.

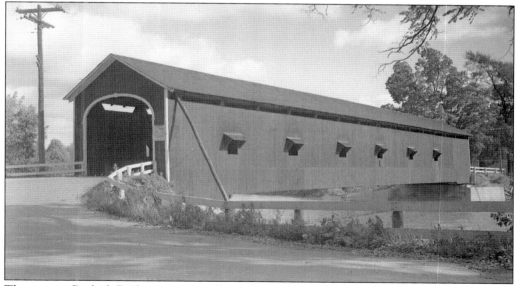

The current Buskirk Bridge was originally commissioned to be built by the towns of Cambridge and Hoosick. Construction began after July 21, 1857, and was completed before November 14, 1857. One would think that the misfortunes of previous bridges at this crossing would have prompted the builders to design for the worst conditions, but in 1880, a flood caused extensive damage to the bridge. (Photograph by Raymond Brainerd; NSPCB.)

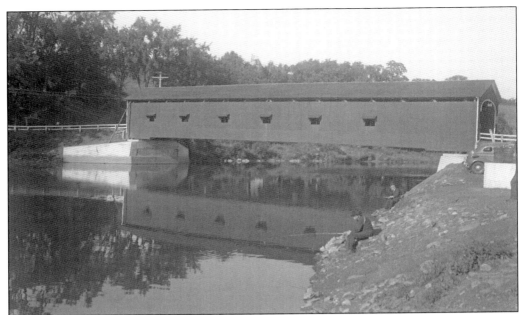

In the flood of 1927, which swept away many covered bridges in the area, two feet of water covered the floor of the Buskirk Bridge. In 1959, ice pushing against the bridge caused it to bow more than a foot in the middle. Ice damaged the bridge again in 1976. After a damaging flood in May of that same year, the bridge was raised two feet.

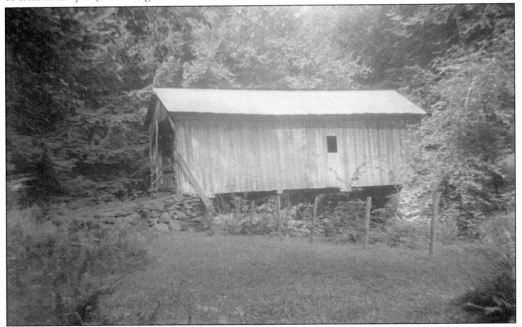

The Copeland Bridge, the only covered bridge still standing in Saratoga County, is maintained by the Edinburg Historical Society and carries pedestrian traffic across Beecher Creek. Built by Arad Copeland in 1879, this 35-foot-long, single-span structure incorporates a queen post truss design and is one of only two queen post truss covered bridges in New York State.

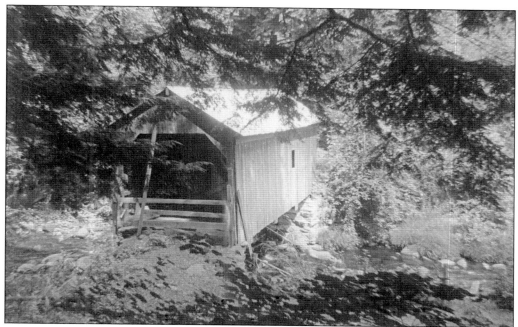

Arad Copeland owned 35 acres across Beecher Creek, which contained gardens and pastureland. An open bridge below the house provided access across this acreage until the bridge was destroyed by melting spring snow and ice. In 1879, Copeland decided to build the covered bridge that still stands today. The house that Copeland built for his new bride around 1832 also still stands across the road from the covered bridge. This beautiful old bridge that Arad Copeland built to get his cows safely to pasture remained in the Copeland family until the fall of 1997, when Copeland's great-great-grandson Robert Tyrrell and his wife, Betty, graciously deeded the bridge to the Edinburg Historical Society. (Below, photograph by Wickwire; TBCBRC.)

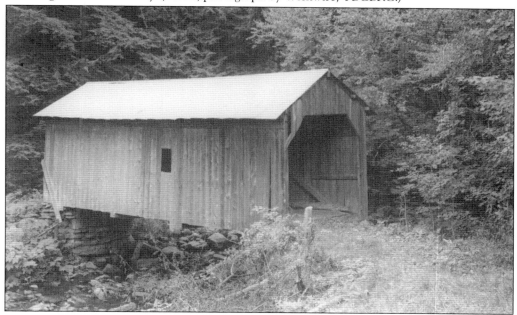

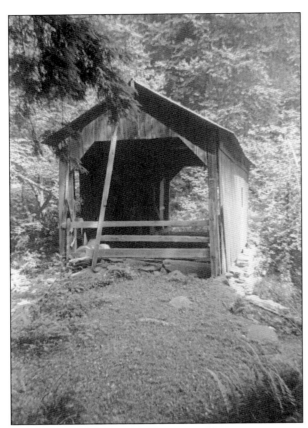

The Edinburg Historical Society received several grants and waged an aggressive campaign to sell "shares" of the Copeland Bridge to raise money for its restoration. Complete restoration of the bridge and 90 percent of the site improvements were done in 2000 and 2001. A rededication celebration for the bridge was held on a beautiful June day in 2002, officially opening the site to the public. The remaining restoration work was completed in 2003.

Over the years, the Copeland Bridge received a new metal roof, new flooring, and new sideboards. Today, it is a popular tourist attraction. The Copeland Bridge has been photographed from all angles, painted by visiting artists, and has even played host to a few wedding ceremonies. (Photograph by Trish Kane.)

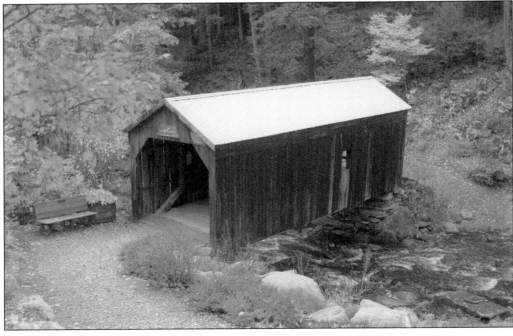

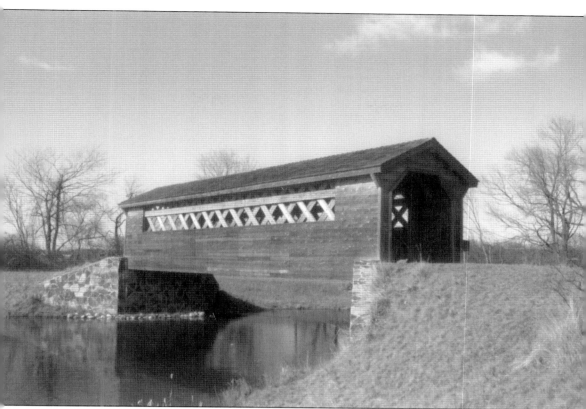

The Ludlow Greens Bridge, the only covered bridge still standing in Suffolk County, is maintained by the owner and carries local traffic across a man-made pond. (Photograph by C. Gary Beckstead.)

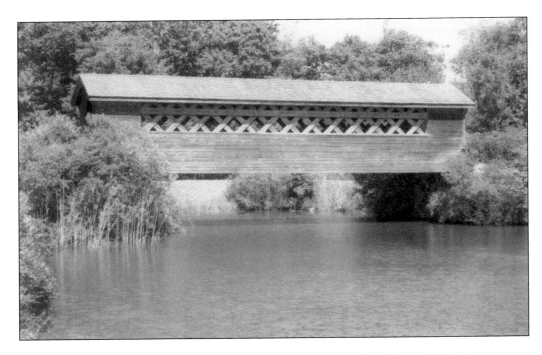

Built by Jonathan Foster in 1990, the 51-foot-long, single-span Ludlow Greens Bridge incorporates the Town lattice truss design. It is one of three covered bridges in New York State with horizontal siding and is located near Bridgehampton at the end of Edgewood Lane. This bridge is visible from the cul-de-sac and serves as an entrance to a housing development. (Both, photograph by George Conn.)

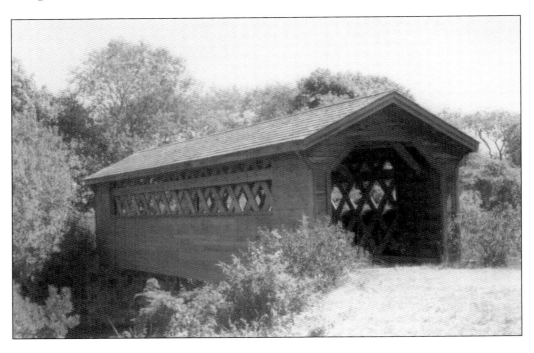

Five
SULLIVAN AND TOMPKINS COUNTIES

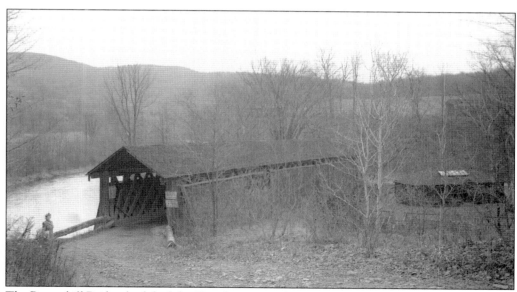

The Beaverkill Bridge, built by John Davidson in 1865, is a 98-foot-long, single-span structure that incorporates the Town lattice truss design. It is owned and maintained by Sullivan County and carries traffic across the Beaver Kill. This is one of four covered bridges still standing in Sullivan County. (Photograph by Raymond Brainerd; NSPCB.)

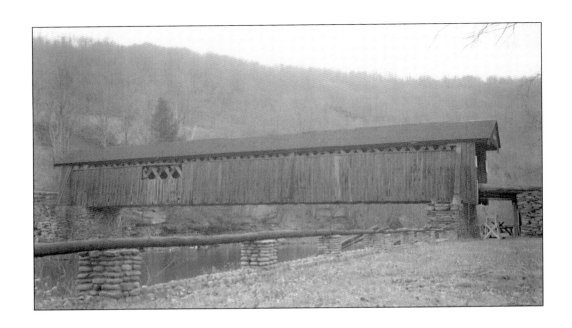

The Beaverkill Bridge is similar in dimensions and design to other bridges in the Catskill region, many of which feature buttresses. It has four buttresses on each side and is one of five covered bridges in New York State that has a timber approach. The above photograph offers a glimpse of the dry-laid stone used in the abutments. This bridge helped bring civilization to a remote area; for much of the early 19th century, northern Sullivan County remained largely unsettled, partly due to ongoing land title disputes from the Hardenburgh Patent and partly due to its ruggedness and shortage of arable land. (Both, photograph by Raymond Brainerd; NSPCB.)

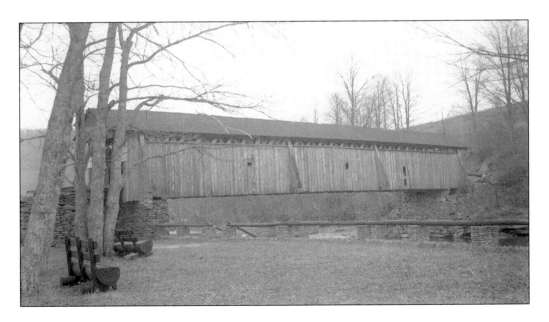

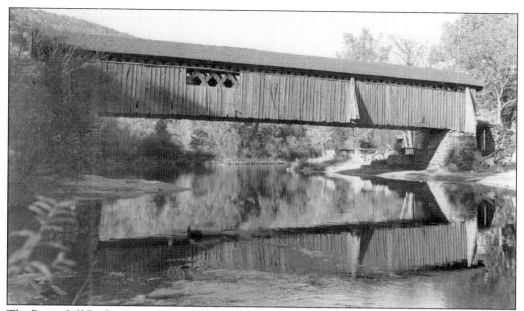

The Beaverkill Bridge was supposedly built by John Davidson. After his marriage, Davidson moved to Shin Creek (now known as Lew Beach), where he farmed, logged, and owned a sawmill while raising a family of 14. One of the younger children said in a 1942 letter that his father had built this bridge along with two other covered bridges over the Willowemoc Creek.

In 1948, the town proposed replacing the Beaverkill Bridge with a more modern metal bridge. It abandoned the plan in response to preservation efforts by local citizens. Instead of demolishing the bridge, the town board spent $700 (about $6,000 in contemporary dollars) to restore it, although it is not known what work was done. The Beaverkill Bridge is owned by the Town of Rockland, but maintenance is provided by both Sullivan County and the New York State Department of Public Works.

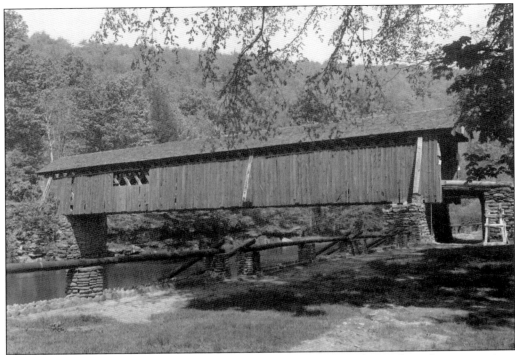

Along with a nearby century-old iron bridge, the Beaverkill Bridge is the only crossing into the rest of the town for residents on the Beaver Kill's north side. Both bridges are regarded as structurally deficient for modern traffic and have reduced load limits. A historical marker near the covered bridge gives credit to the Civilian Conservation Corps for their work in building this state park.

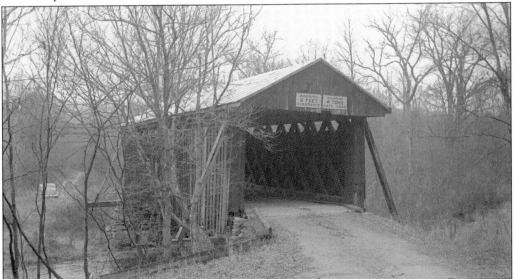

The Bendo Bridge is owned and maintained by Sullivan County and carries limited local traffic across Willowemoc Creek. The Willowemoc Creek is well known as one of the best fishing creeks in the area. (Photograph by Raymond Brainerd; NSPCB.)

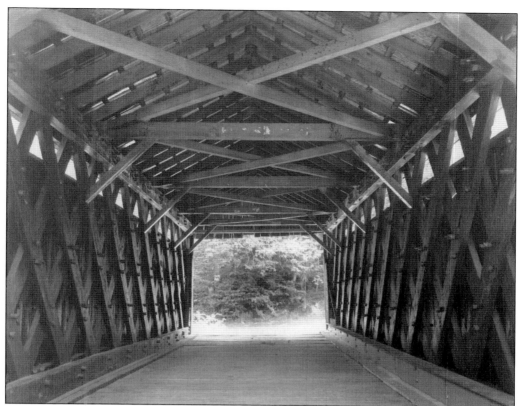

Originally built by John Davidson in 1860 in Livingston Manor, New York, this 48-foot-long, single-span structure incorporates a Town lattice truss design and has a timber approach. The original Town truss design no longer actually supports this bridge, so it is now classified as a Stringer. In 1913, the Village of Livingston Manor decided to build a new bridge. Half of the covered bridge was moved to its current location, where it is known as the Bendo Bridge. When it was reerected, the bridge was shortened to 48 feet in length. When visiting this bridge, note the trunnel holes in the decking that indicate where parts of the original bridge were used in the reconstruction process. (Below, photograph by Raymond Brainerd; NSPCB.)

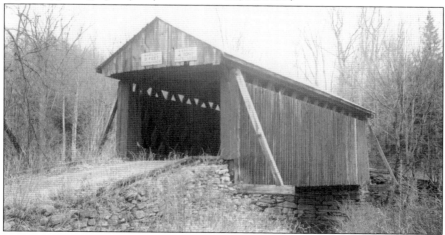

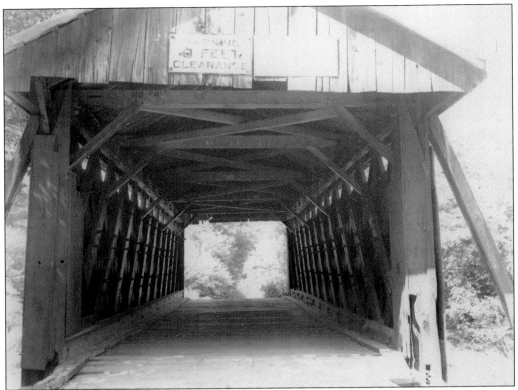

The Bendo Bridge originally stood just off Main Street in the village of Livingston Manor where a small, open king post span was connected to one end of the bridge. Older photographs of the bridge's interior show the bridge covered with numerous advertisements. This was typical inside many covered bridges—what better place for advertisements than on a bridge everyone in the area has to travel across?

The Halls Mills Covered Bridge is the last remaining symbol of a community established by early settlers of the Upper Neversink Valley, led by John Hall, a Quaker preacher. This bridge was built across the Neversink River after floods took out an earlier covered bridge. (Photograph by Raymond Brainerd; NSPCB.)

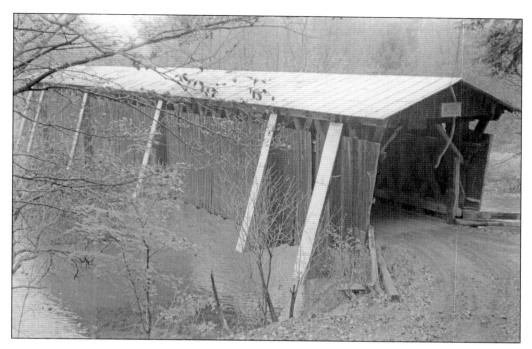

The Halls Mills Bridge is similar in dimensions and design to other bridges in the Catskill region, most of which feature buttresses. It has six buttresses on each side and has a timber approach. Built in 1912 by David Benton (a private contractor) with assistance from John Knight and George Horbeck, this 119-foot-long, single-span structure incorporates the Town lattice truss design. Because of its isolated location, it is an easy target for vandals and graffiti. There is also evidence of a past fire on the deck of the bridge. (Below, photograph by Trish Kane.)

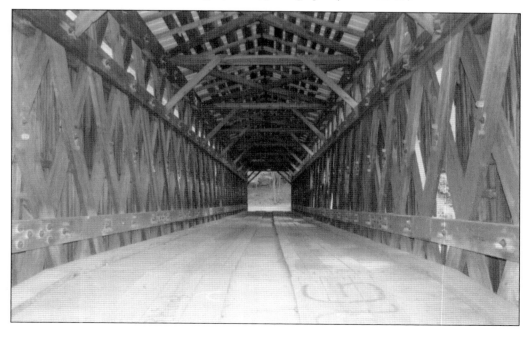

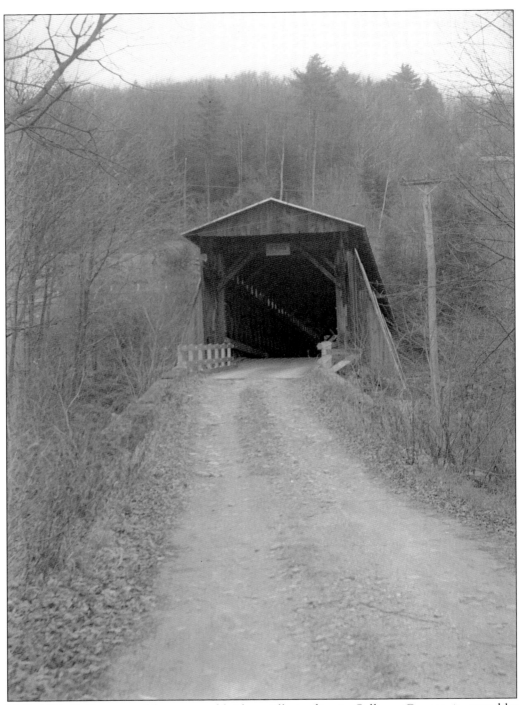
Halls Mills Bridge, one of four covered bridges still standing in Sullivan County, is owned by the Town of Neverskink and maintained by the county; it carries pedestrian traffic across the Neversink River. It stands amongst a beautiful setting in the Catskill Mountains. (Photograph by Raymond Brainerd; NSPCB.)

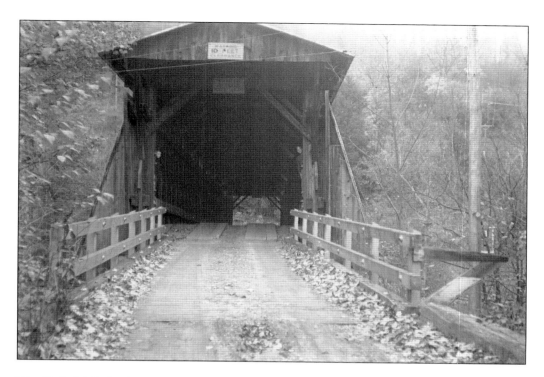

The Halls Mills Bridge stands strong but no longer has a destination. It was bypassed in 1963, and a small, contemporary bridge now crosses the river farther upstream. The dominance of the Neversink River is demonstrated every time flooding occurs near the Halls Mill Covered Bridge. (Below, photograph by Linda Schott.)

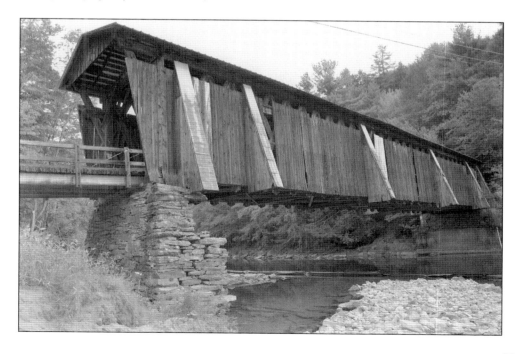

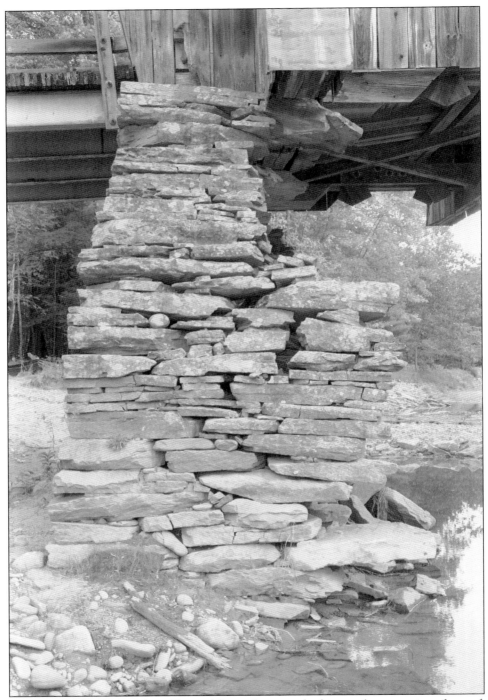

In August 2011, floodwaters from Tropical Storm Irene washed away a large portion of one of the abutments of this bridge, and the entire bridge was almost lost forever. Thanks to the concentrated efforts of locals, Sullivan County officials, and the New York State Covered Bridge Society, the Halls Mills Bridge is still standing. (Photograph by Linda Schott.)

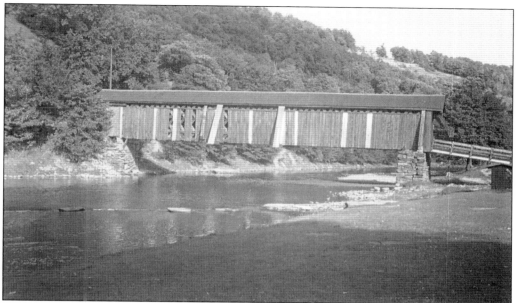

The Van Tran Bridge (formerly known as the Motts Flats Bridge) is one of four covered bridges—and the oldest—still standing in Sullivan County. It is owned and maintained by the county and carries traffic across Willowemoc Creek. Travelers on Route 17 between New York and Binghamton can easily see this bridge when traveling west near Livingston Manor. Built by John Davidson in 1860, this 117-foot-long, single-span structure incorporates the Town lattice truss design with laminated arches added in 1985. Davidson built this bridge five years before he built the Beaverkill Bridge.

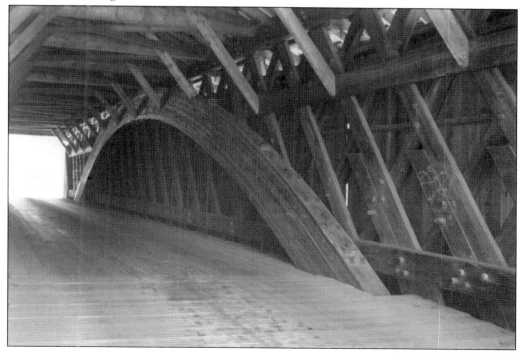

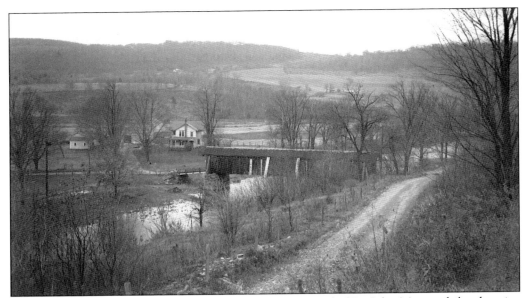

The house adjacent to the Van Tran Bridge is the homestead of Dr. John Mott—philanthropist, winner of the Nobel Peace Prize, and founder of the YMCA. Although the sign in the adjacent Livingston Manor Covered Bridge Park states that this bridge is listed in the State and National Registers of Historic Places, that is incorrect; to date, the Beaverkill Bridge is the only covered bridge in Sullivan County listed in the state and national registers. (NSPCB, Brainerd.)

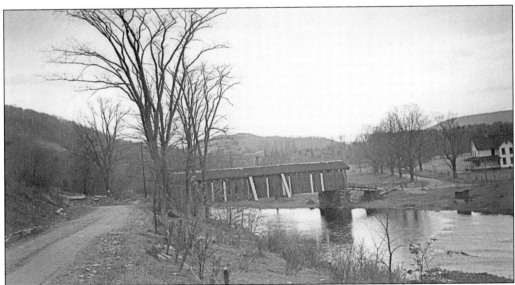

On August 26, 1940, the Van Tran Bridge was damaged by a heavily loaded truck. The truck made an enormous hole in the decking as it plunged into the Willowemoc Creek. Repair costs came to $437.75 in materials and $174.80 in labor. Of the eight men who completed the repairs, working four 11-hour days, the top salary went to the truck driver who earned 80¢ per hour. Some of the other laborers made a mere 50¢ per hour. (Photograph by Raymond Brainerd; NSPCB.)

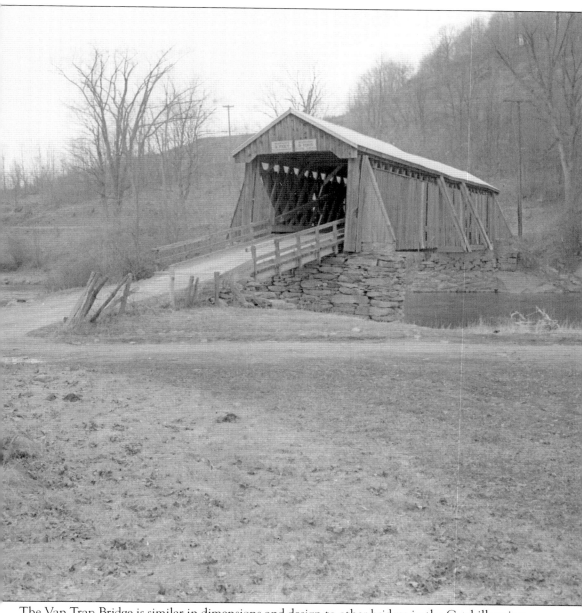

The Van Tran Bridge is similar in dimensions and design to other bridges in the Catskill region. This bridge has four buttresses on each side and has a timber approach. (Photograph by Herbert Richter; NSPCB.)

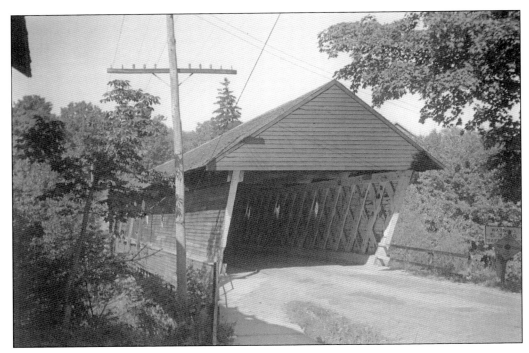

Newfield Bridge is the only covered bridge still standing in Tompkins County. It is owned and maintained by the Town of Newfield and carries traffic across the West Branch of Cayuga Creek. It is the oldest covered bridge in New York State still open to daily traffic. Built in 1853 for $800, this 115-foot-long, single-span structure incorporates the Town lattice truss design (with laminated arches that were added in 1972). It is one of three covered bridges in New York State with horizontal siding.

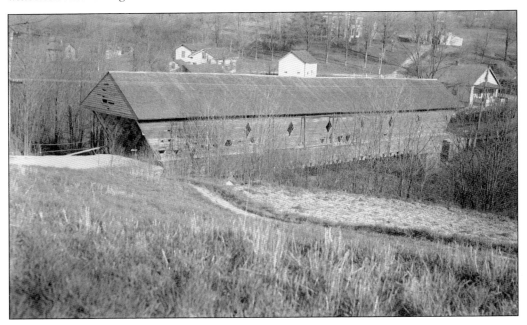

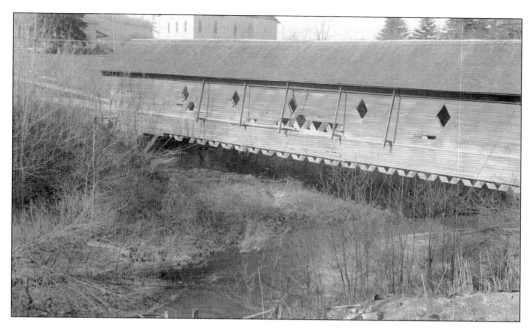

Stonemasons Benjamin Starr and Dick Russell laid the abutments for the Newfield Bridge. The carpenters who worked on the bridge were Samuel Hamm and his sons, David and Sylvester, and David Dassance and Patchen Parsons. Daniel Tunis turned all the wooden pins, called trunnels (also known as treenails), that secure the Town lattice truss. Tompkins County's lone surviving covered bridge stands farther west than any of the other covered bridges in the state. It occupies a log bridge site that dates back to 1812, when the hamlet was called Florence. So far, it has been impossible to locate definite information about the log bridge, as all the town records (with the exception of the 1811 town minutes) were destroyed by a fire in June 1875.

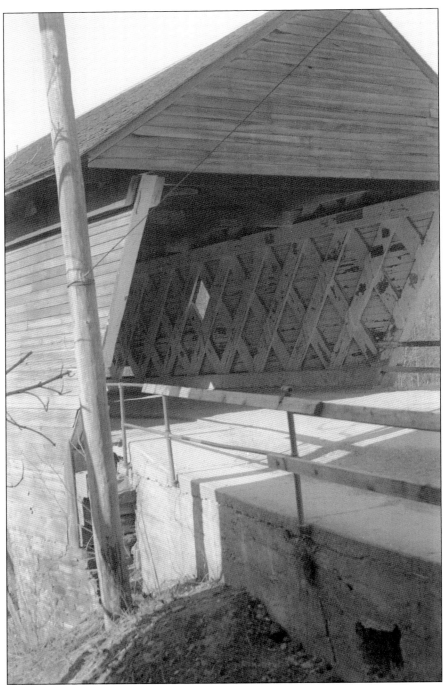

During its 161 years in operation, the Newfield Bridge has survived many floods. On June 1, 1905, a flood swept away four or five dams above the covered bridge, washing tons of sand and gravel against the old bridge. Several small fires have also been reported on the bridge, but little damage was done at any one time. The most recent fire incident on the bridge occurred on November 1, 2002.

Six
ULSTER COUNTY

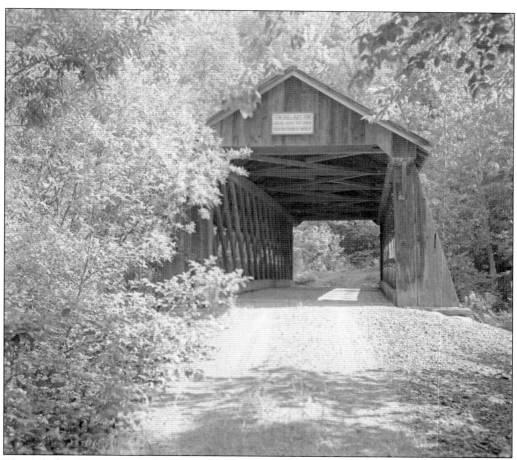

The Ashokan-Turnwood Bridge (formerly known as the Olive Bridge, Barrington Lodge, and New Paltz Campus Bridge) is one of five covered bridges still standing in Ulster County. It is currently maintained by the Ashokan Foundation and carries pedestrian traffic across Esopus Creek. It was moved to its current location from Turnwood, New York, in 1939. Lester A. Moehring, comptroller for the Chrysler Corporation, bid and won the structure for $1. (Photograph by Herbert Richter; NSPCB.)

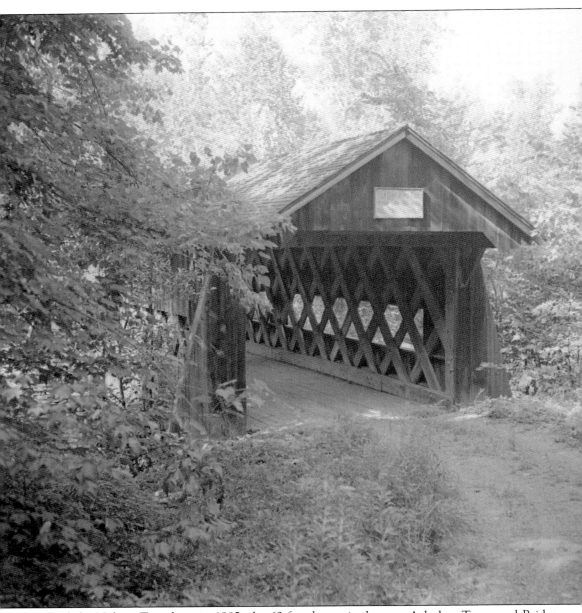

Built by Nelson Tompkins in 1885, the 62-foot-long, single-span Ashokan-Turnwood Bridge incorporates the Town lattice truss design. Before it was moved to its current location (where it is still in use), this bridge did not have a paid "bridge snower," as was the custom in the late 19th century. Instead, travelers carried their own shovels and, if necessary, spread out enough snow to get their sleighs across the bridge. (Photograph by Joseph Conwill.)

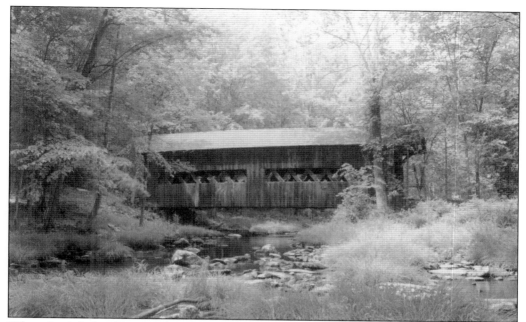

When the Ashokan-Turnwood Bridge stood in Turnwood, New York, the principal road leading to it passed through the covered bridge near the junction of Cross Mountain and Beaverkill Roads. The bridge sat quite close to Turnwood's center of activity. Children often visited the local store to buy hot roasted peanuts, and it was not uncommon for the youngsters to go to the bridge to play and climb inside of it. (Photograph by Trish Kane.)

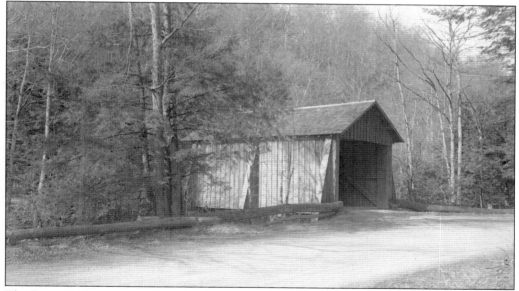

The Forge Bridge sits on private land and is maintained by the owner, former US ambassador Kingdon Gould Jr. Gould purchased this bridge from the town, and his son Caleb restored it in 1976. Built by Salem Jerome Moot in 1906, the 27-foot-long, single-span structure incorporates the king post truss design. It is one of two king post covered bridges in New York State. Today, it only carries pedestrian traffic across Dry Brook. (Photograph by Raymond Brainerd; NSPCB.)

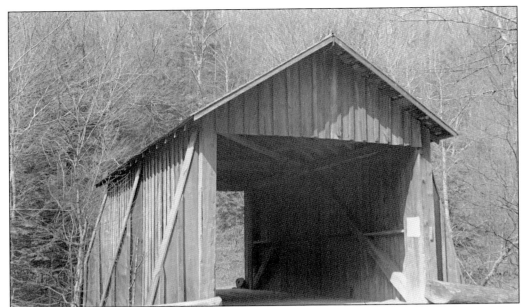

Supposedly, Forge Bridge got its name from an iron forge that stood near the bridge and Dry Brook. Colonial ironworks—both forges and furnaces—were built beside non-failing sources of water in order to generate the power needed to run the huge bellows that intensified the heat used for smelting and to run large trip hammers. Pictured here is the Forge Bridge before the wooden gates were added.

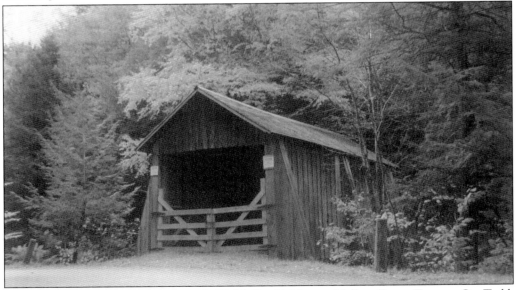

At one time, the Rider Hollow, Lincoln Todd, Gould, Haynes Hollow, Forge, Tappan, Ort Todd, and Myers covered bridges all stood over the Dry Brook in Ulster County. With the exception of the Forge, Myers, and Tappan Bridges, the other bridges washed away in 1901. The historic Myers Bridge was removed in 1989 and replaced with a modern bridge with a roof and sides covering a concrete deck. Sometime during the 1970s, wooden gates were added to the Forge Bridge. (Photograph by Trish Kane.)

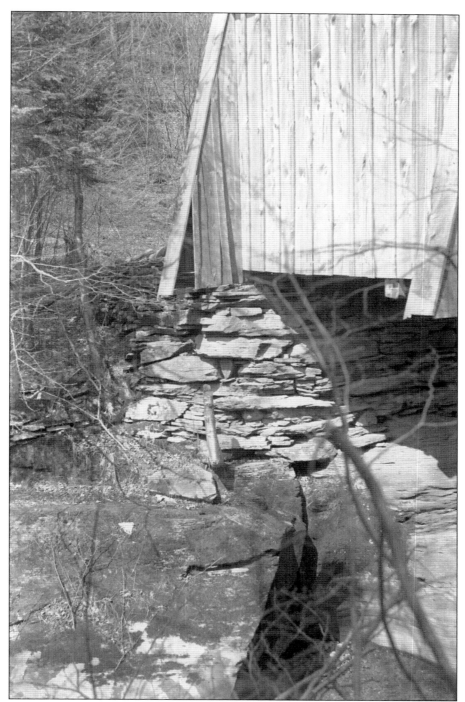

During the late 1800s, a stringer-type bridge spanned Dry Brook exactly where the current Forge Bridge now stands. It was an open structure with waist-high sides and a king post truss design. This photograph shows a wonderful example of the dry-laid stone used in the abutments of the Forge Bridge.

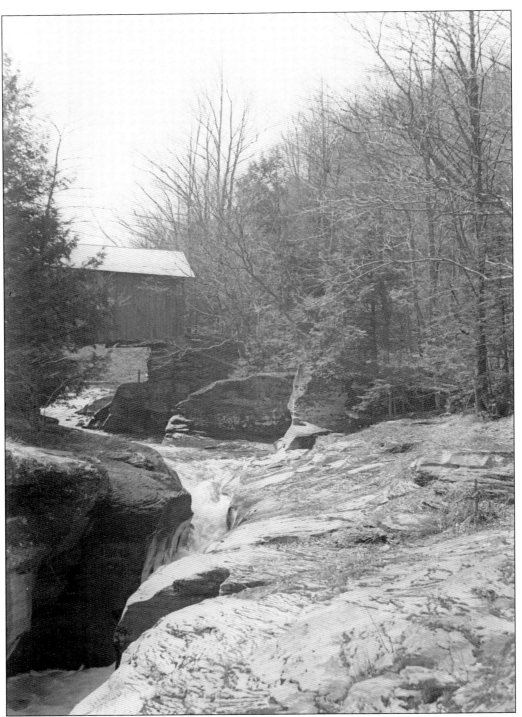
There is a beautiful sight immediately downstream from the Forge Bridge, where swift running water has worn the sandstone bedrock into beautiful curves, deep cuts, and variously sized potholes. Visitors can check out these natural formations when visiting this bridge.

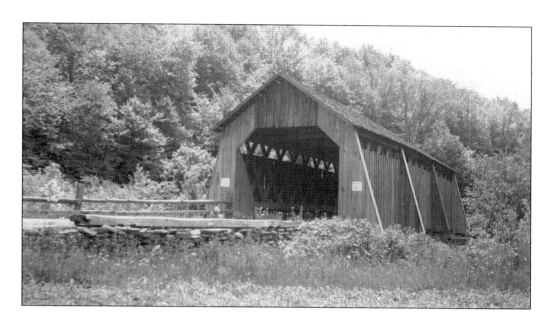

The Mill Brook Bridge (formerly known as Grants Mill Bridge) is owned and maintained by the Town of Hardenburgh and carries pedestrian traffic across Mill Brook. In the summer of 1902, the Commission of Highways asked for bids to build a covered bridge over Mill Brook. Edgar A. Marks was the low bidder and, along with his brother Orrin, built the covered bridge in the fall of that year. Wesley Alton assisted them, and Daniel George of Dry Brook framed the timbers. This 66-foot-long, single-span structure incorporates the Town lattice truss design. The total cost to build this bridge was $1,027.

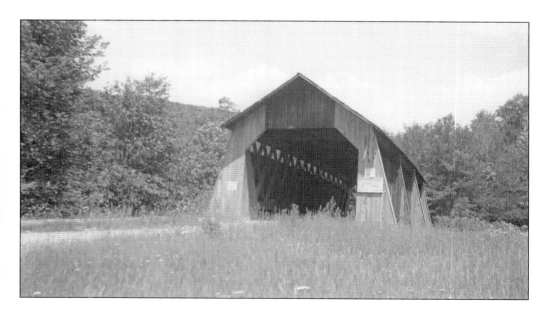

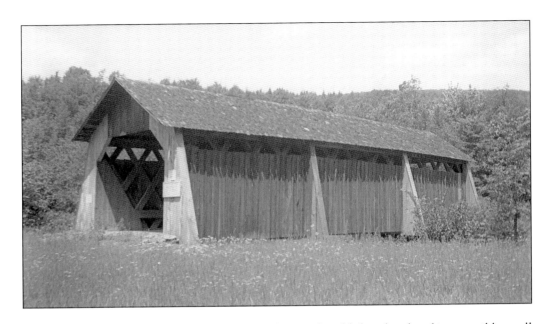

In September 1964, the Mill Brook Bridge was bypassed and left isolated and inaccessible to all but foot travelers. A culvert-type road bridge was built just above it to accommodate traffic. The bridge was rehabilitated in 1991 by Bob Vredenburgh, great-grandson of Edgar A. Marks, one of the bridge's original builders. To assist in the funding of the rehabilitation, trunnels were sold to individuals with the stipulation that their names would be imprinted on them. When visiting the bridge, people can look for the names of individuals who supported the rehabilitation effort. (Below, photograph by Trish Kane.)

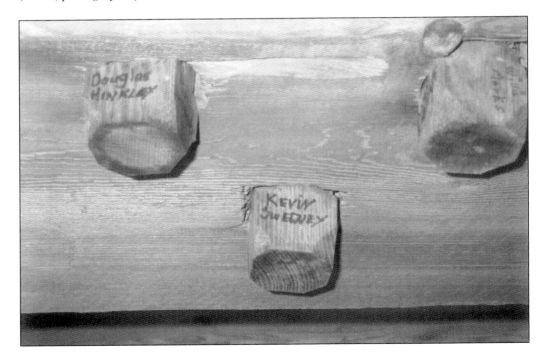

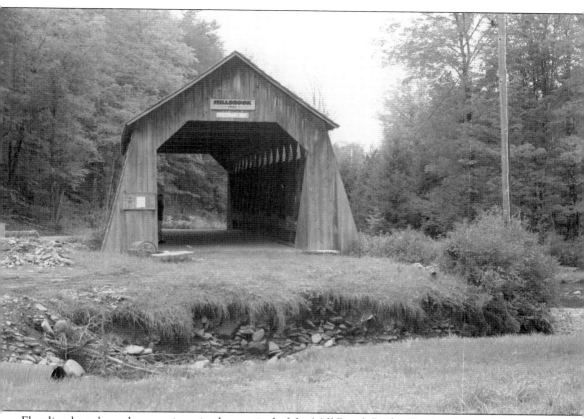

Flooding has always been an issue in the survival of the Mill Brook Bridge. During Tropical Storm Irene in 2011, floodwaters eroded most of the area surrounding the bridge. If not for a nearby concrete bridge, which stopped a tree from floating downstream, this bridge would have been lost forever. (Photograph by Trish Kane.)

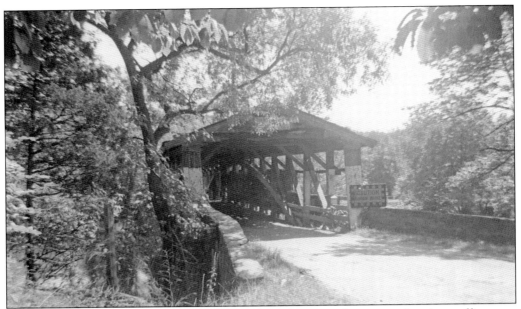

Perrine's Bridge is owned and maintained by Ulster County and carries pedestrian traffic across the Wallkill River. It was named for French Huguenot immigrant James Perrine, who owned a tavern/hotel near the bridge site. The name Perrine is pronounced with a long "I" and is sometimes shortened by locals so that it sounds like "Pine's Bridge." Following the death of his father, James Perrine, James H. Perrine managed the family tavern/hotel. Between 1858 and 1860, the tavern/hotel also served as the local post office. A "bridge snower" conveniently lived by the tavern/hotel—his job was to keep the bridge floor covered with snow in the winter so sleds could cross, thus the term "snowing the bridge." Built by Benjamin Wood in 1844, this 154-foot-long, single-span structure incorporates the Burr arch design patented in 1817. It is one of two authentic Burr arch truss bridges in New York. The total cost to build this bridge in 1844 was approximately $2,200.

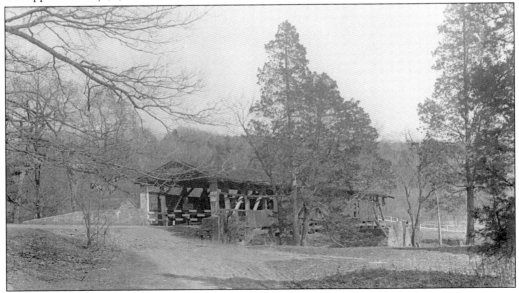

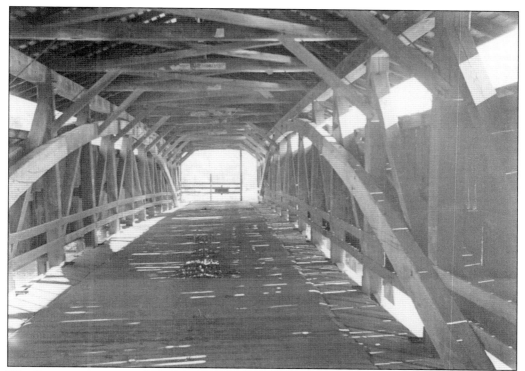

The first repairs on record for the wooden Perrine's Bridge occurred in 1917. By the early 1930s, there was growing concern that the span was weakening. This time, repairmen attempted to strengthen the structure by putting several tons of beams under the flooring, but this only increased the strain on the already weakened arches. In early January 1967, a large rally was held at the bridge to commence a campaign for its restoration. About 300 people attended in support of the effort. One interesting banner displayed on the side of the bridge during that time quoted Proverbs 23:10, "Remove not the old landmarks and enter not into the fields of the fatherless."

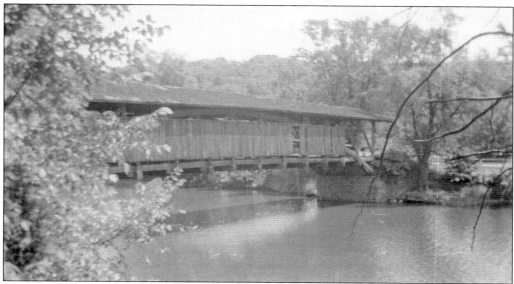

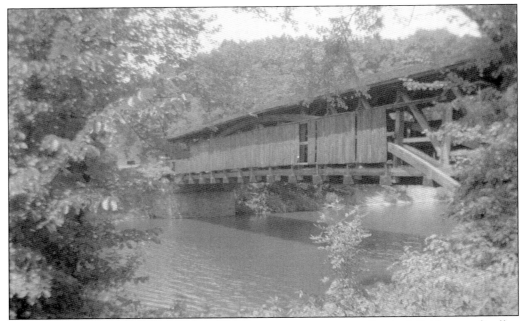

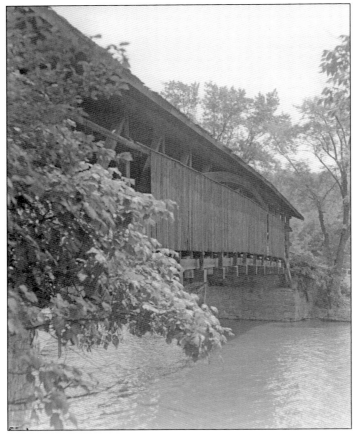

Perrine's Bridge was finally restored, and on June 29, 1969, rededication ceremonies took place at the bridge. This covered bridge still exists today because of efforts by the Rifton community. When traveling north on the New York State Thruway near New Paltz, people can look for this bridge—it is visible from the highway. But while driving 65 miles per hour, travelers will have to look quickly to see it.

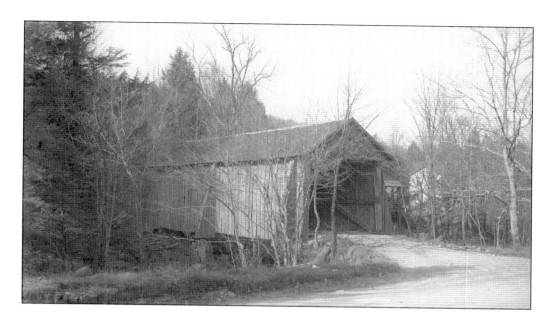

Tappan-Kittle Bridge is owned and maintained by the Town of Hardenbergh and carries local traffic across Dry Brook. Built by Salem Jerome Moot in 1906, this 43-foot-long, single-span structure once incorporated a king post truss design. The original king post truss design, however, no longer actually supports this bridge as it was originally designed, so it is now classified as a Stringer bridge. This wooden span has quietly served its purpose for many years, vibrating as travelers passed through its portals while braving severe floods and watching decades of seasons merge into each other. (Above, photograph by Raymond Brainerd; NSPCB.)

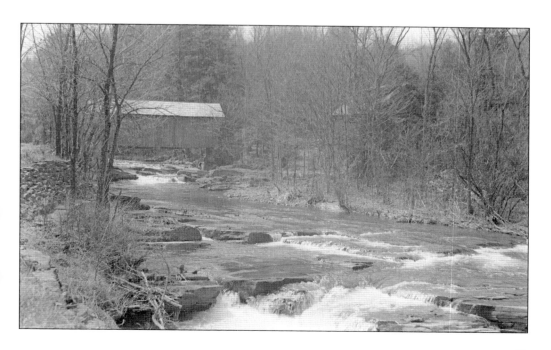

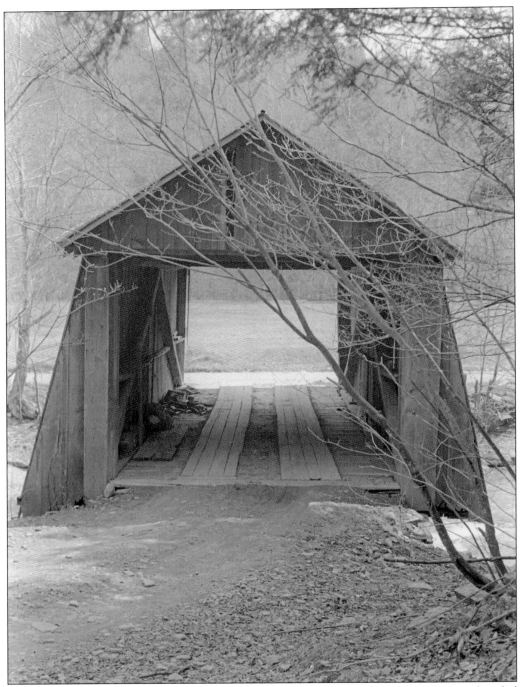

Time eventually took its toll on the little Tappan-Kittle Bridge. In 1974, the roof was reshingled with red asphalt. Poles were wedged from the brook bed below to help support the trusses, and in the summer of 1976, workers attached cables from nearby trees to the underside timbers to offer lifting support. This bridge has been totally rebuilt and is now supported by I-beams; only part of the framing comes from the original bridge.

Seven
Washington County

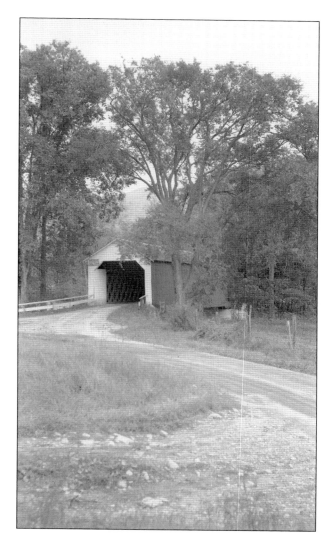

Eagleville Bridge is one of four covered bridges still standing in Washington County. It is owned and maintained by the county and carries traffic across the Batten Kill. Built by Ephraim W. Clapp in 1858, this 100-foot-long, single-span structure incorporates the Town lattice truss. (Photograph by Raymond Brainerd; NSPCB.)

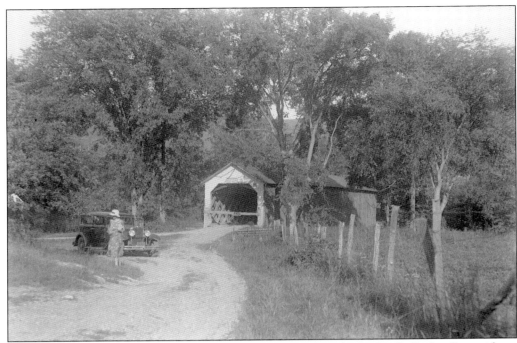

At least two unknown bridges at this crossing date earlier than the Eagleville Bridge. For residents of Eagleville, the bridge made for easy access across the river to Cambridge and Vermont. After 1853, when the railroad arrived, those who wanted to catch a Delaware & Hudson Railway passenger train or ship goods by freight could travel south to the Cambridge depot or northwest to the Shushan depot. Despite floodwaters, high winds, and harsh winters, Eagleville Bridge has staying power. In March 1977, high waters undermined the east abutment, causing it to drop into the river. A Washington County bridge crew saved it in the nick of time, then made repairs later that summer, and the bridge was once again opened to traffic. (Below, photograph by Roger D. Griffin; NSPCB.)

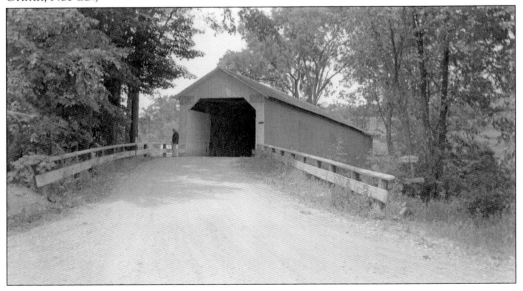

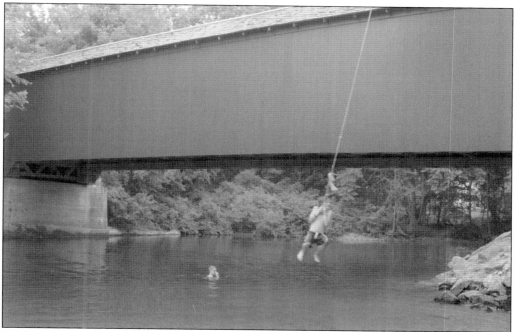

On hot summer days, traffic jams and noise threaten the famous tranquility of the Batten Kill, but the Eagleville Bridge remains a popular swimming hole for the young and adventurous. (Photograph by Trish Kane.)

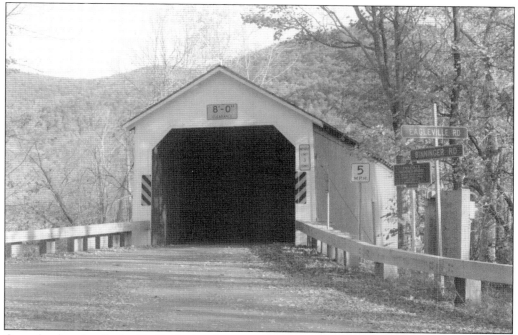

Over the decades, Eagleville Bridge has been re-sided, reroofed, and repainted a number of times. In the 1940s, the paint scheme was Venetian red with white trim. During a rehabilitation in 2006 and 2007, the bridge was once again painted a Venetian red color. (Photograph by Trish Kane.)

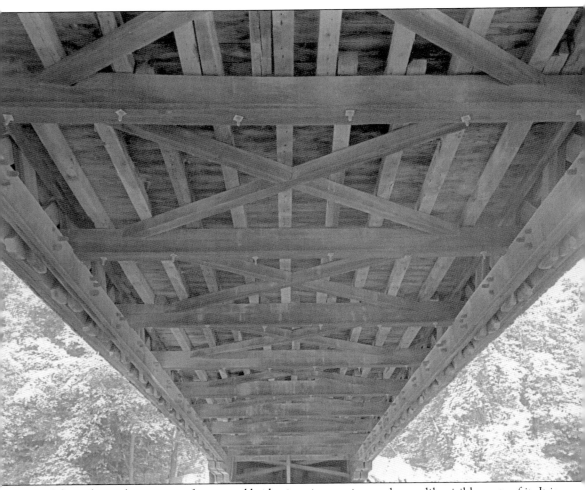

Often, the undercarriage of a covered bridge is as interesting as the readily visible parts of it. It is a special treat to find historical floor framing today because many covered bridges have had their decks replaced with hidden steel beams. This photograph offers a unique look at the intricate details of the deck work and some of the Town truss of the Eagleville Bridge. (Photograph by Joseph Conwill.)

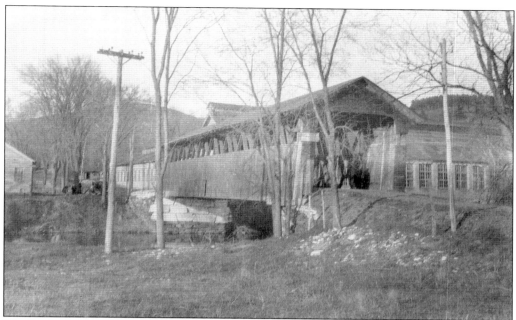

The Rexleigh Bridge is owned and maintained by the county and carries traffic across the Batten Kill. This 107-foot-long, single-span structure incorporates the Howe truss design. It is one of only three Howe truss bridges in New York State. The photograph below was taken shortly after the famous 1927 floods that took out a covered bridge downstream on Route 22. This image offers a quality view of the south abutment before it was encased in concrete; the bridge is only sided three-quarters up, and the white line near the bottom of the bridge indicates how high the water reached during the flood.

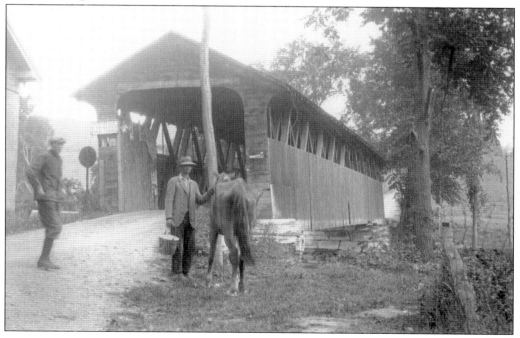

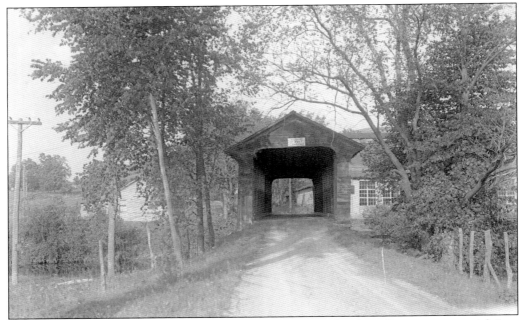

The unique cast iron "shoes" on the Rexleigh Bridge were used to fit timbers into joints with iron rods. This feature, patented by R. Comins, from Troy, New York, has never been incorporated into any other known covered bridge in the United States. The need for a modern crossing at the Rexleigh site became acute when the railroad arrived around 1853. The bridge provided a vital link to rail service for farms on the south side of the Batten Kill.

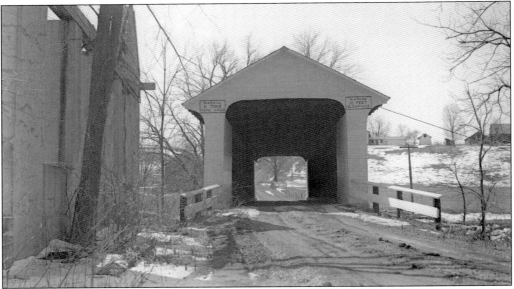

Flooding in 1927 almost swept the Rexleigh Bridge downstream. Another major flood in 1938 washed out a dam upstream. In 1965, the approach roads were changed in such a way that water drained from the road onto the bridge. A severe flood in 1977 undermined the southwest abutment, causing the bridge to settle. This, combined with structural damage caused by rot, led to the closing of the bridge on September 7, 1977.

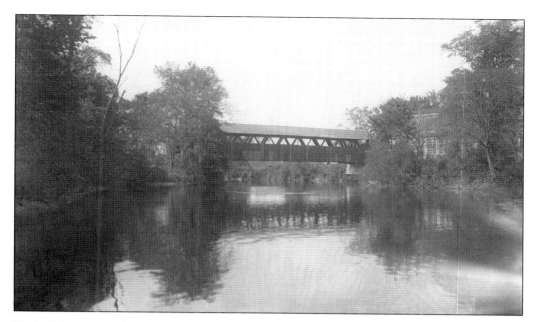

Rexleigh Bridge stood in a decaying state as wood beetles ate away at the main supporting structures. By 1979, Washington County decided to demolish the bridge and replace it with a newer steel-and-concrete structure. The demolishing did not sit well with concerned citizens. A petition that garnered 1,500 names requested that the covered bridge be saved; fortunately, this bridge is still standing. Both the Rexleigh and Eagleville Bridges stand above popular swimming holes. Kicking a hole in the siding to jump through is a long-standing misuse of the bridge; inspection doors and ventilation ports have been employed in the past to help reduce the destruction. (Below, photograph by Trish Kane.)

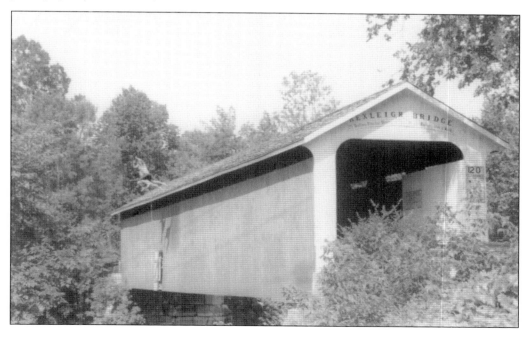

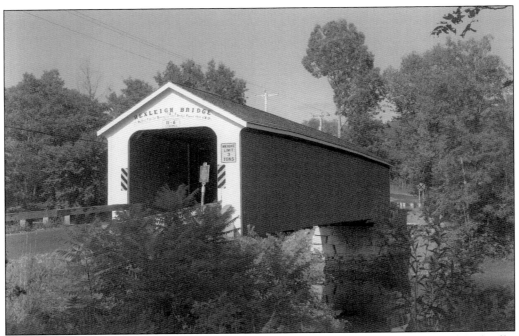

On August 4, 2007, Washington County hosted a celebration for the newly rehabilitated Eagleville, Rexleigh, and Buskirk Bridges. Washington County has been (and should be) commended for its efforts to preserve its covered bridges. (Photograph by Trish Kane.)

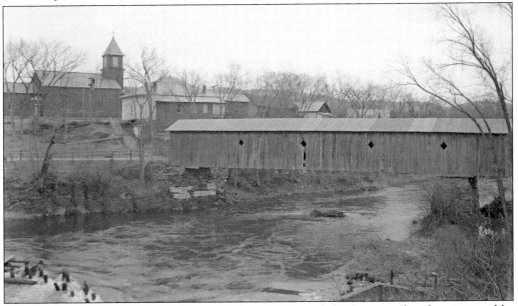

The Shushan Bridge crosses the Batten Kill and is the only bridge owned and maintained by the Town of Shushan. The bridge was abandoned by the county as a bridge in 1962 and sat in disrepair for over 10 years until it was saved by the Shushan Covered Bridge Association, which converted it into a museum. A collection of period machinery and farm implements, many in working order, are used by visitors for hands-on demonstrations.

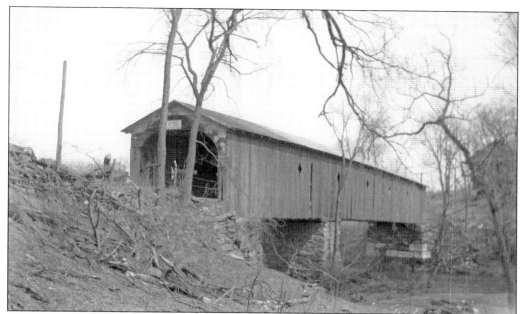

Built by brothers Milton and Andrew Stevens during the spring and summer of 1858, the 161-foot-long, two-span Shushan Bridge incorporates the Town lattice truss design. The bridge trusses were laid out and assembled on the village green beside the railroad depot, then drawn by oxen to the bridge site, where they were erected over the river on a system of falsework. When it was originally built, the center of the bridge was supported by a large pier made of dry-laid stone. As shown in the photograph below, when the dam washed out in the flood of 1927, the 20-feet-square pier became an obstruction in the fast-flowing stream; it was replaced by a narrower pier in 1938.

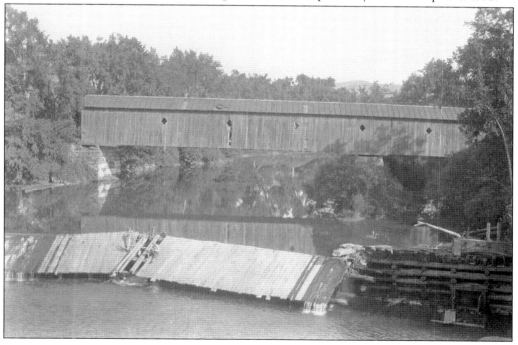

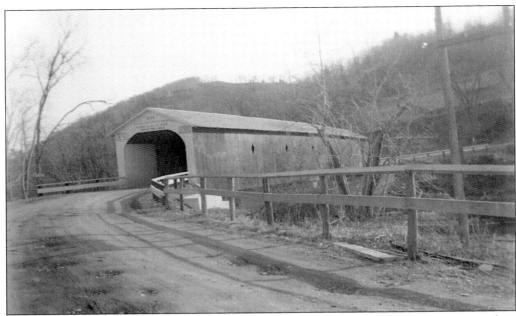

Shushan Bridge has 46 panels, each three-and-a-half feet on centers. All truss timbers are white pine, spruce, or hemlock fastened at the joints by trunnels of either red oak or locust. The total weight of the bridge, including the roof and siding, is estimated at 80 tons. The Shushan Bridge stood as the longest single-span covered bridge on the Batten Kill for over a decade. During that time, however, a leaking roof caused damage to the upper chords, leading to the bridge's near collapse in 1974. An alert crew of Shushan residents noticed the bridge visibly sagging and managed to temporarily prop it up with telephone poles, which saved the bridge. In 1962, a new steel bridge was built that bypassed the Shushan Bridge. The sign on the bridge reads: "Five dollars fine for rideing or driveing on this bridge faster than a walk."

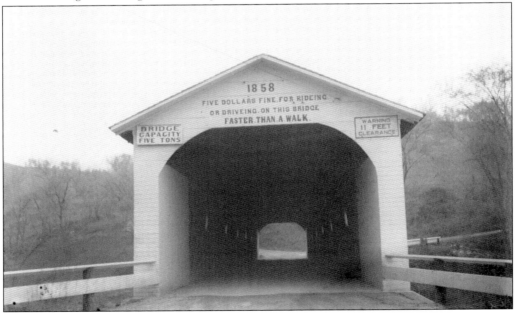

Eight
COVERED SPANS OF YESTERYEAR

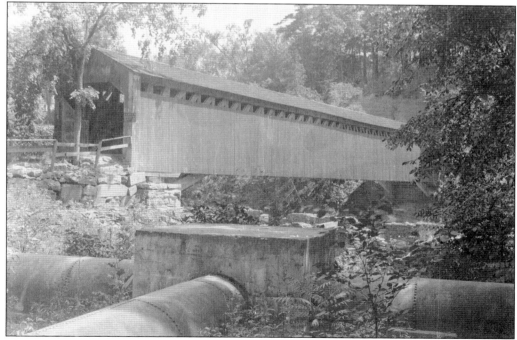

This bridge, located in Albany County, has been known by two names: French's Mill (due to the village where it was located) and French's Hollow (because of the swimming hole near the bridge). It was built by Henry Witherwax in 1869 after a freshet swept away a previous wooden bridge.

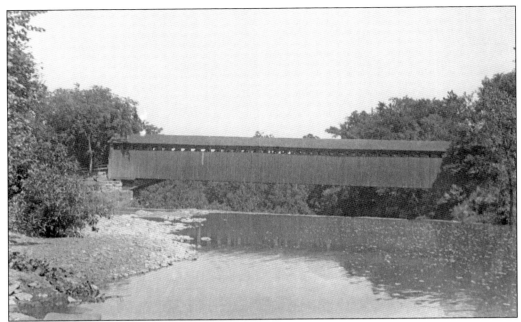

The French's Mill Bridge was the last full-size highway covered bridge in Albany County. It was a single span and stretched 162 feet over the Normans Kill near Guilderland Center, New York, and carried the old Schoharie Road, which was charted in 1799 and used extensively for the trade of goods coming through the Mohawk River Valley to the port at Albany. Because of its location over the hollow, the bridge amplified the sounds of horses' hoofs and wagon wheels, making them sound like thunder audible from some distance away. The area below the bridge served as a popular area for swimming, fishing, and picnicking.

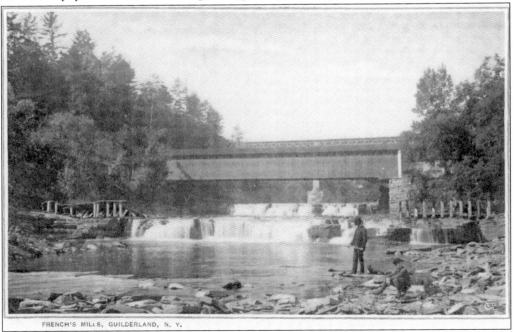

FRENCH'S MILLS, GUILDERLAND, N. Y.

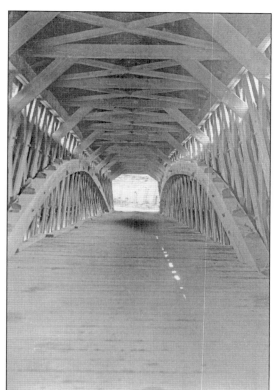

When Henry Witherwax built the French's Mill Bridge, he used the Haupt patent truss invented around 1839 by Herman Haupt, a railway engineer, who was later noted as the builder of the Hoosac Tunnel. Haupt's design used lattices in pairs inclined toward the center, vertical members, and a pair of arches. The photograph below shows a clear view of the lattices and their incline toward the center. The ends of the arches are well supported by the abutment.

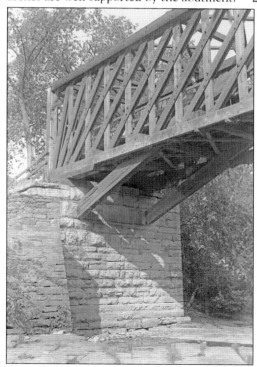

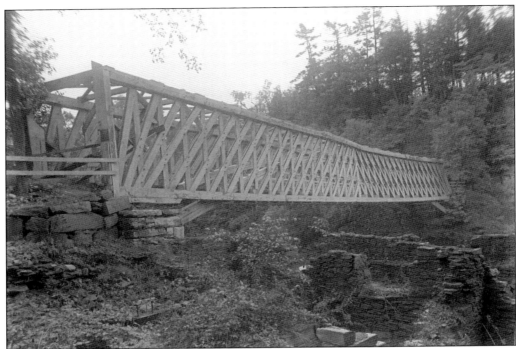

After 64 years of service, the French's Mill Bridge was found to be too weak for traffic and was replaced by the Albany County Highway Department during the summer of 1933. The above photograph, taken during the dismantling process, shows the rare Haupt truss and the slanted truss members. For many years, French's Hollow was a popular recreational area in the cool waters of the Normans Kill. The hollow was named after Abel French, who opened a knitting factory at the forge in the early 1800s.

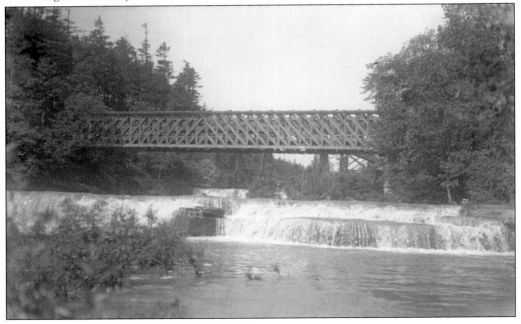

In this photograph, taken soon after the French's Mill Bridge was dismantled in 1933, remnants of the bridge are still visible on the left bank, and a portion of the abutment is visible at right.

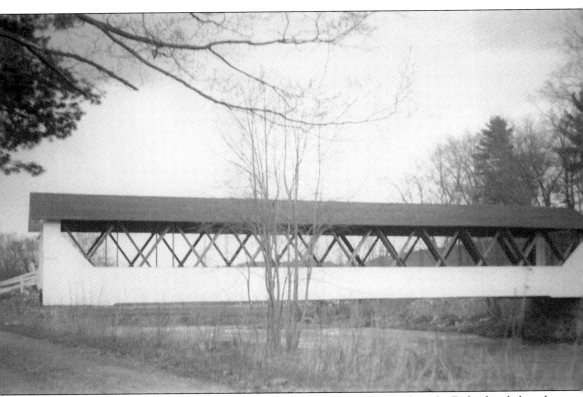

The Riders Mill Bridge area was known as Mosher's Mill until 1802, when the Rider family bought the property. Both Rider and Mosher operated a gristmill, sawmill, and fulling mill there. Riders Mill is close to Interstate 90 near the border of Rensselaer County.

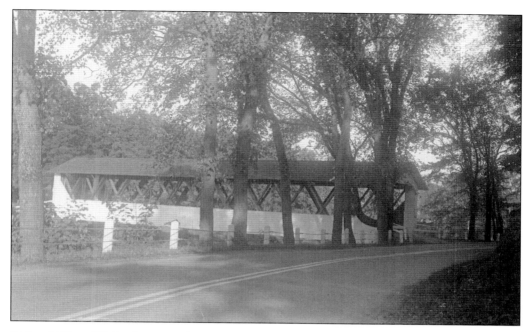

Riders Mill, a 115-foot-long, single-span bridge, was located in Columbia County and was the last surviving covered bridge in the county. It succumbed to a midsummer freshet in July 1945. Earl Wixson, a local resident, recalled that he watched as the Kinderhook Creek inched higher and higher until it reached the floorboards of the bridge. Wixson was on his way to the bridge to knock out some of the sideboards to relieve pressure from the rushing water, but as he approached, one end of the structure lifted up, and it was quickly dislodged from its abutments.

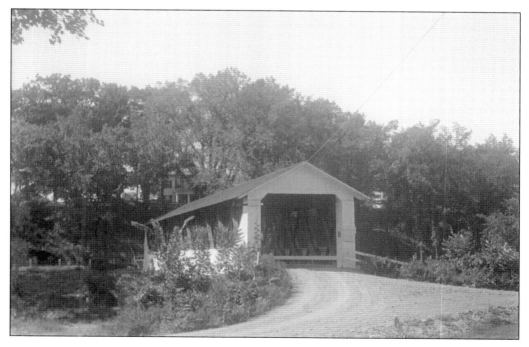

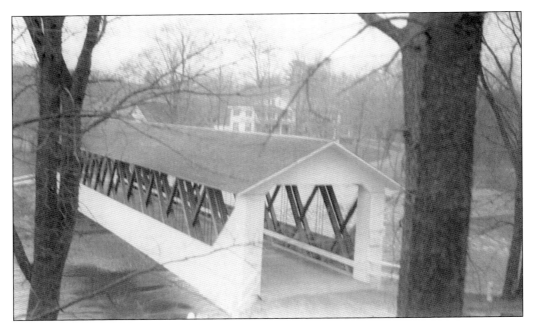

In the 1945 flood, the covered span was washed downstream and smashed into the Malden Bridge. Soon after, both bridges traveled downstream to their final destination at Malden Bridge Flats. Both bridges were a total loss. This was not the first time the Riders Mill Bridge had been washed away, however—in 1866, another freshet took out the bridge, but it was saved and reset on its abutments. After that flood, a herd of cows was used to test the bridge's strength. The 1937 photograph below shows the Howe truss replacement bridge built in 1870 after the disastrous flood of 1869; the 1936 Ford in this image belonged to famed covered bridge expert Richard S. Allen.

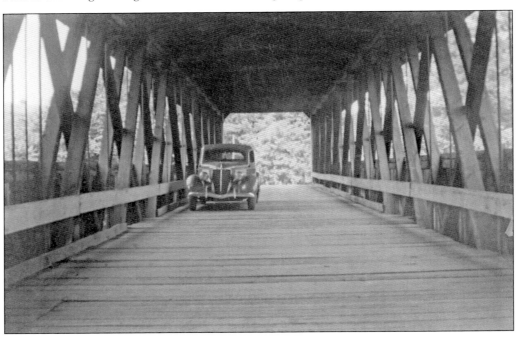

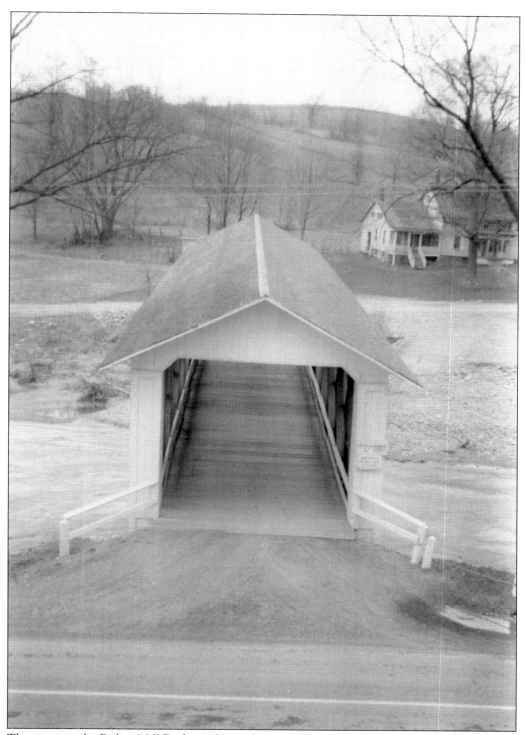

The signs on the Riders Mill Bridge indicate that on May 3, 1940, the date this photograph was taken, the clearance was 11 feet, and the weight limit was 3 tons.

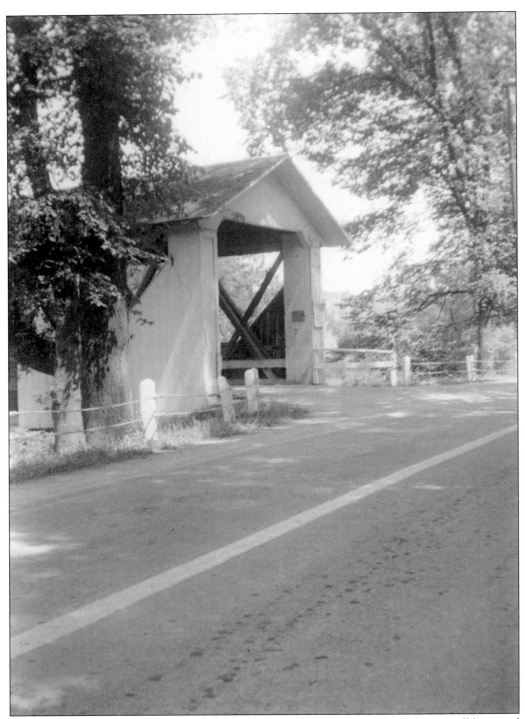
Covered bridge expert Richard S. Allen describes the Riders Mill Bridge as being well kept and painted white with a green shingled roof. The bridge sat in a lovely location and, sadly, was never replaced after its destruction in 1945.

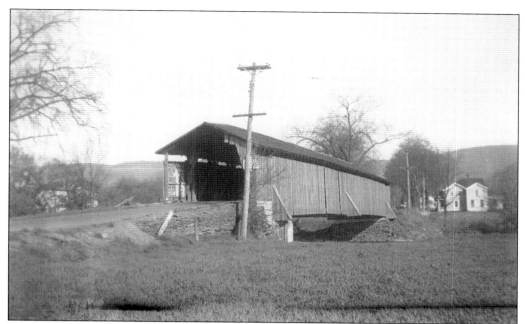

The small village of DeLancey is in Delaware County and located on the West Branch of the Delaware River. Robert Murray constructed the DeLancey Bridge in 1859, the same time he was building the Hamden Bridge located one mile south. The original construction cost for this bridge was approximately $1,000. The DeLancey Bridge was a 118-foot, single-span structure and was built using the Long truss. Because the bridge had a low clearance, it was not a favorite of truckers. Some have postulated that this is why, on August 14, 1940, around 2:00 p.m., the bridge was set ablaze and soon collapsed and fell into the river.

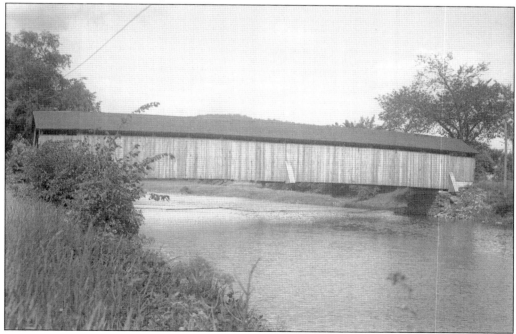

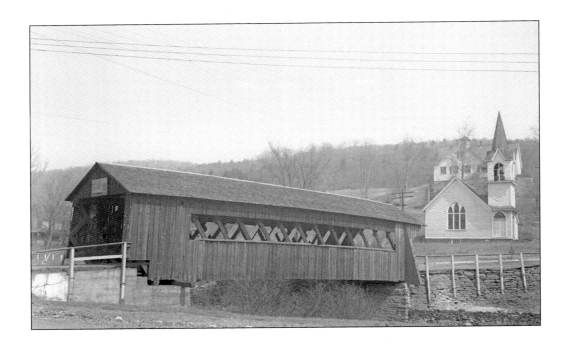

The Halcottsville Bridge was located in Delaware County just north of Margaretville in the small village of Halcottsville. Halcottsville is named for a family that settled in the area, on the banks of the East Branch of the Delaware River, in 1803. Brothers William and John Utter built the bridge in 1870, and it displayed a Town lattice truss. The 75-foot-long bridge crossed the East Branch of the Delaware River in the heart of the village.

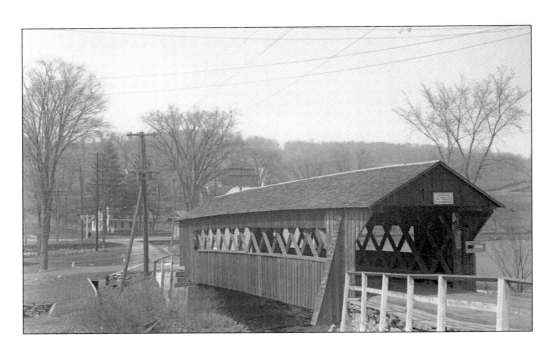

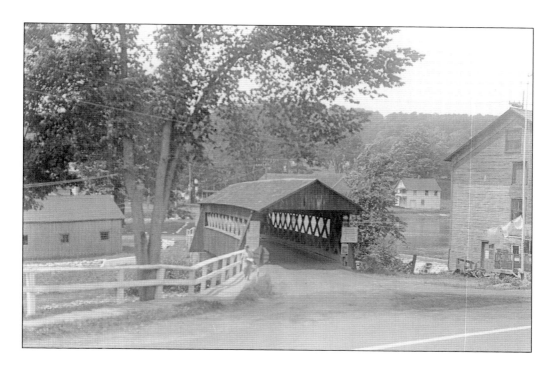

The Halcottsville Bridge had full-length windows along each side, a wooden shingle roof, and buttresses at the portals. The buttresses were typical of covered bridges in the Catskill region. At one time, Halcottsville was a busy place with as many as six general stores, a tailor and dressmaking shop, a law office, a shoe shop, a meat market, and a millinery. The arrival of the Delaware & Ulster Railroad in late 1871 not only aided businesses and farms, but spurred the tourist trade. This covered bridge played an active role in the small community.

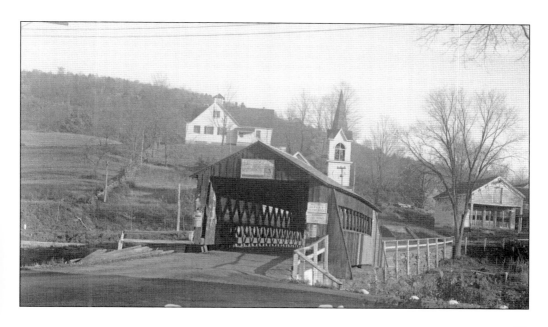

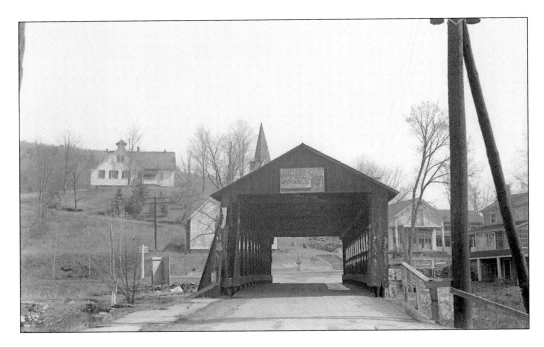

The Halcottsville Bridge sat in a lovely location in the village. The above image shows the church steeple in the background; this steeple is visible in many photographs of this bridge, and the church still exists today. A stone dam that created Lake Wawaka was just upstream from this bridge. The lake produced waterpower necessary to run the gristmill located next to the covered bridge. The mill was so close to the portal of the bridge that it was part of the entrance for the mill. The photograph below, taken from downstream, shows water passing over the stone dam.

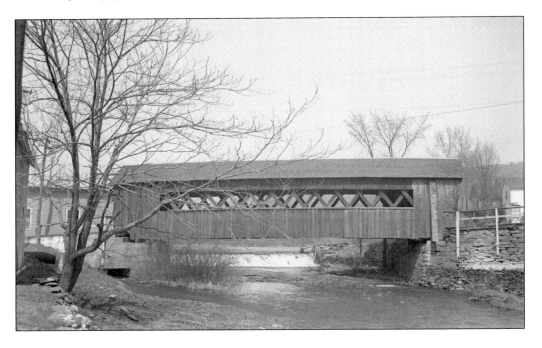

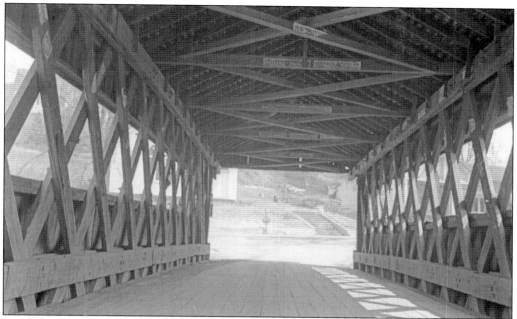

In 1948, when the Halcottsville Bridge was demolished, part of the truss—showing the joints and some posters that were still intact—was sent to the Smithsonian Institution in Washington, DC, at the request of famed covered bridge expert Richard S. Allen.

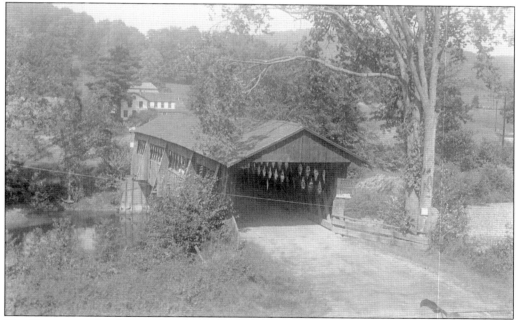

The Dunraven of today is a hamlet of residences and small farms. But 160 years ago, it was a thriving industrial center known as Clark's Factory (after a family that ran a tannery and several other enterprises there). By the time the Delaware & Eastern Railroad built a station in the area in 1907, the community was known as Dunraven for unknown reasons. This bridge—Halls Bridge—was located just west of Dunraven in Delaware County.

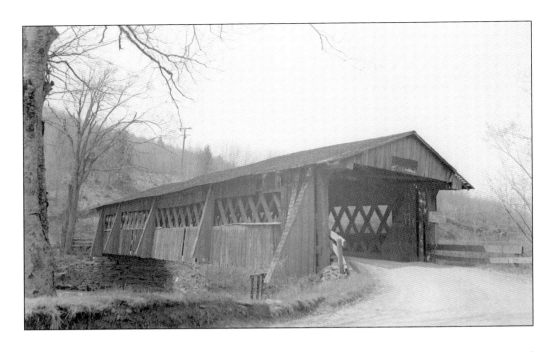

In 1870, William Mead and Nelson Thompson built the 130-foot-long Halls Bridge, constructed using a Town truss, across the East Branch of the Delaware River. The construction of the Pepacton Reservoir in the early 1950s resulted in the removal of several buildings in the Dunraven area, including this covered bridge. Additional buildings in the area were removed when New York rebuilt Route 28 in the 1960s.

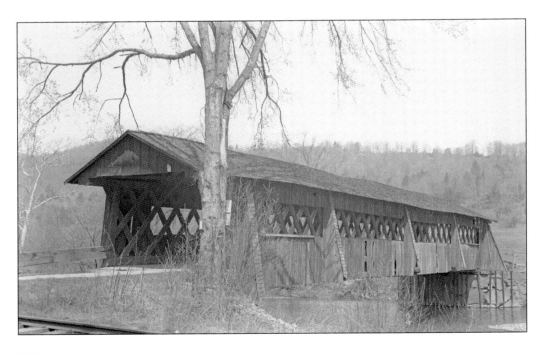

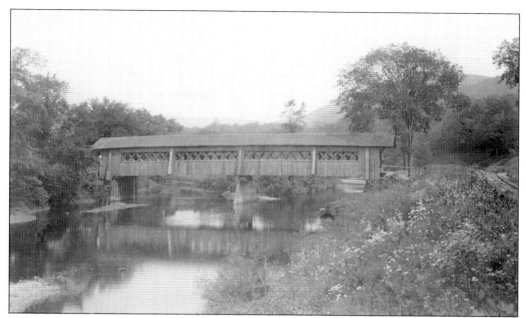

Halls Bridge was often described as the most beautiful covered bridge in Delaware County because of its picturesque surroundings.

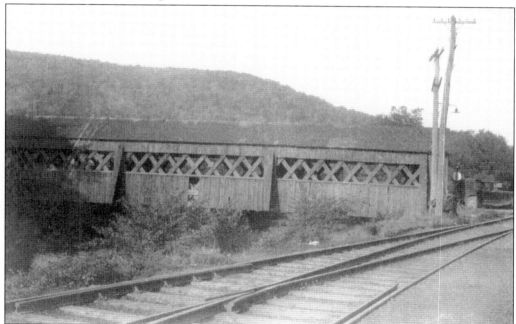

The hamlet originally known as Middletown Center was renamed Margaretville in honor of a descendant of Robert Livingston, holder of the 500,000-acre Hardenburgh Patent that encompassed this area. Robert Murray built the Margaretville Bridge across the East Branch of the Delaware River in 1865. On several other occasions, Murray used a Long truss, but he used a Town truss for the Margaretville Bridge. Trunnels used in its construction were turned out in George W. Stimpson's Novelty Shop and transported to the bridge site by wagon.

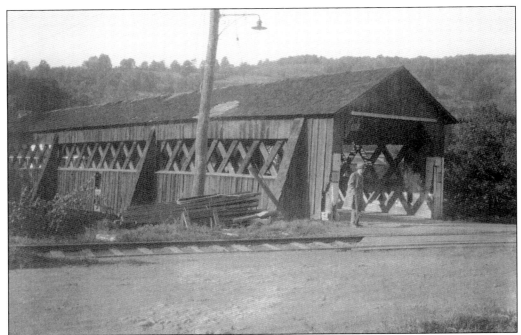

In October 1932, the Margaretville Bridge was moved 50 feet downstream to make room for the construction of a new bridge. When the new bridge was completed, the old covered bridge was torn down. The replacement bridge is in the same location where the covered bridge once stood. The above photograph clearly shows the large openings on both sides of the bridge and the railroad tracks that ran immediately in front of the bridge.

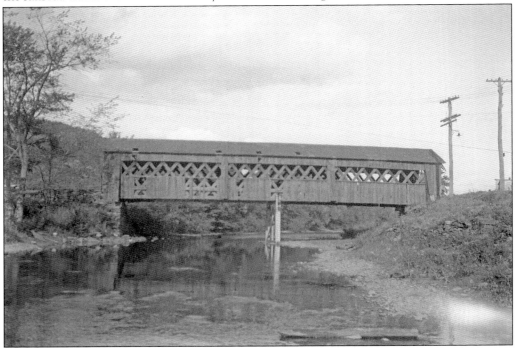

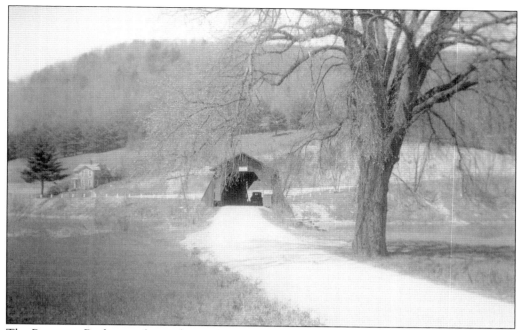

The Pepacton Bridge was located in Delaware County in the village of Pepacton. It was the last bridge in New York (and one of very few in the country) that displayed a Haupt truss. This unique bridge connected Route 30 to the village of Pepacton. Although the builder of the bridge and date of its construction are not certain, many believe it was built by Robert Murray of Andes, New York, in 1857; Murray built several covered bridges in the area in the mid-1800s.

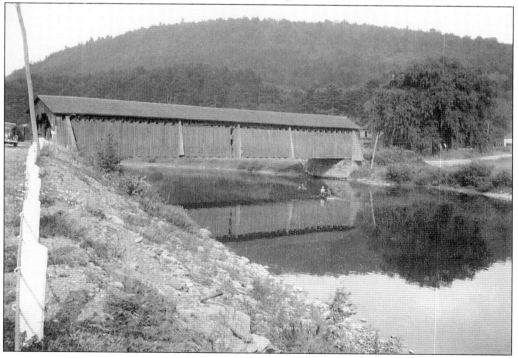

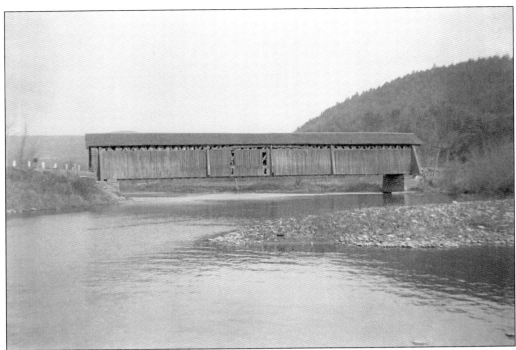

The Pepacton Bridge crossed the East Branch of the Delaware River and measured 168 feet in length with a clear span of 145 feet. Braced by large buttresses, the Pepacton Bridge displayed five on each side—with two larger ones at each portal. In 1839, Herman Haupt of Philadelphia, Pennsylvania, patented an "improved lattice" design for wooden bridges that incorporated an arch with his own special lattice system. It appears that the Pepacton Bridge used the Haupt system, as it had an arch on each truss.

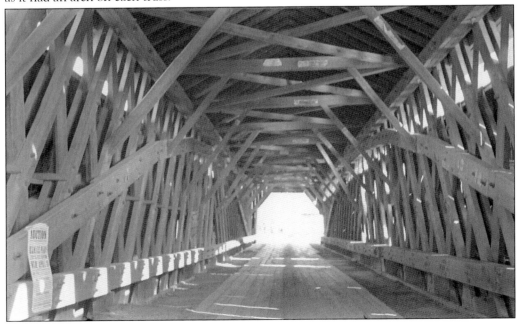

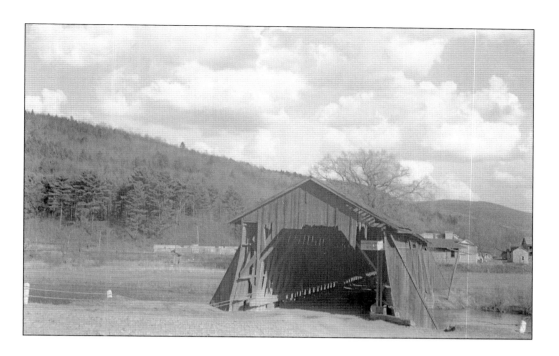

November 25, 1950, was doomsday for the Pepacton Bridge. Extremely high winds lifted the bridge off its abutments and carried it 250 yards downstream, where it landed on its side. Perhaps this was a blessing in disguise, as the Downsville Dam (completed in 1954) created the Pepacton Reservoir, and this bridge would have either been removed or found itself resting under the reservoir's waters.

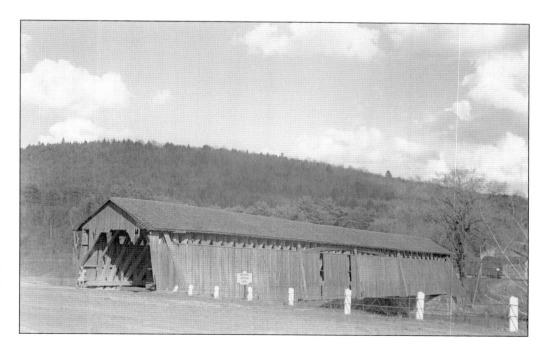

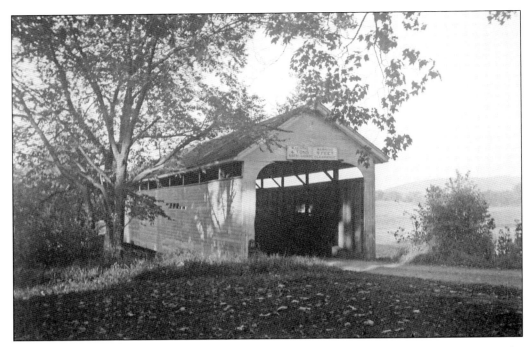

The village of Unadilla was formed in Otsego County in 1792. It lies at the confluence of the Susquehanna and the Unadilla Rivers and is watered by the many tributaries of these rivers. Unadilla is pleasantly situated on the north bank of the Susquehanna River. The Unadilla Bridge crossed the Ouleout Creek near Unadilla, about one mile from where the Ouleout emptied into the Susquehanna River. The township's early importance was due to the 1802 construction of the Catskill and Susquehanna turnpike, an important highway that terminated in Unadilla.

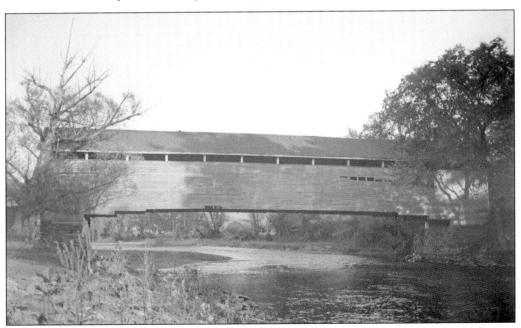

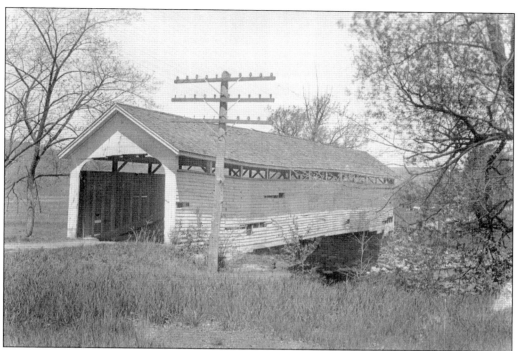
Solomon Youmans built the Unadilla Bridge in 1874. Youmans was a local farmer and carpenter who lived on the Delaware County side of the Susquehanna River, just across from Unadilla.

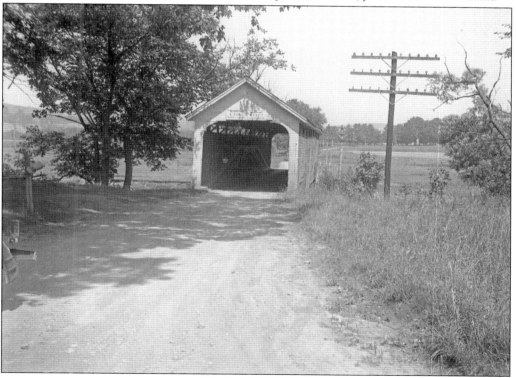

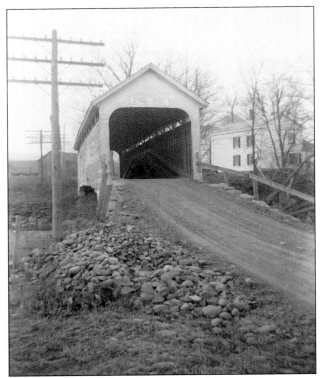

The sign across the portal reads: "Warning: 4 Tons Safe Load/ Warning: 9 Feet Clearance." This bridge was removed during the week of May 25, 1956. Although the bridge has been gone for 58 years, the road it was on is still called Covered Bridge Road. This bridge's truss was a perplexing one—it appears there are three queen post trusses stacked on each other with a king post supporting the queen post trusses. Although this is not a patented truss type, it seemed to work, as the bridge lasted for over 82 years in this location.

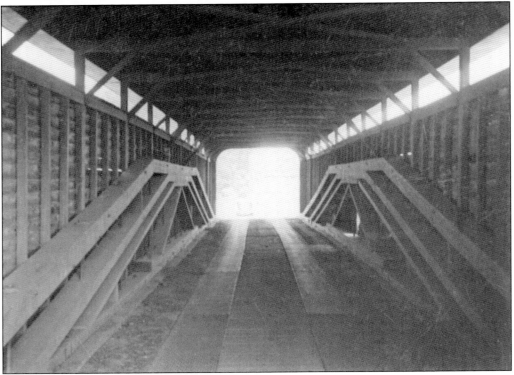

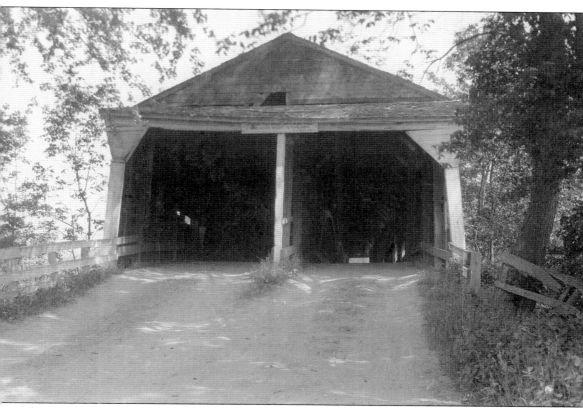

The Fish House Bridge, one of New York's longest covered bridges, was located in Fulton County near Northampton. The residents of Fish House were proud of the covered bridge that had been hewn from pine logs in 1818 to span the Sacandaga River. The 400-foot-long, two-span structure had three Burr arch trusses in each of the spans. Timber for the bridge came from virgin forests in the Fish House area and was hewn at the bridge site.

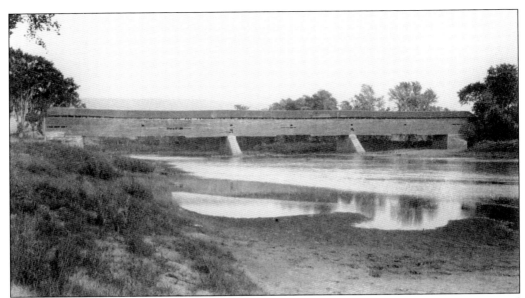

The Fish House Bridge was built by a young Saratoga engineer, Daniel Stewart, and his experienced crew—friendly natives and Jacob Shew, son of the first Fish House settler, Godfrey Shew. Jacob Shew, a member of the state legislature, won a grant of $5,000, and the town of Northampton raised the other $500 to build the bridge. Trees used for the lower chords were reported to have been 96 feet in length. This bridge—along with the community of Fish House—is now under the waters of the Sacandaga Reservoir (now called Great Sacandaga Lake). In 1929, in preparation for the flooding, homes were torn down or moved. The covered bridge was left standing in hopes that it could be saved. Villagers used steel cable to lash both ends of the bridge to tree stumps, hoping it would defy the high water and later be moved to another location.

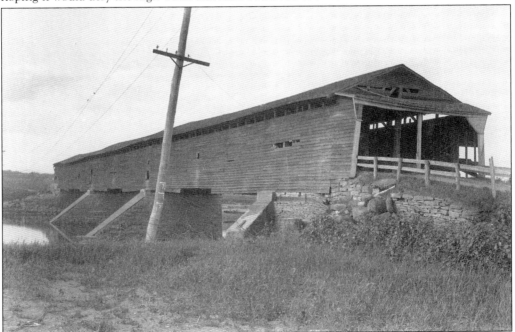

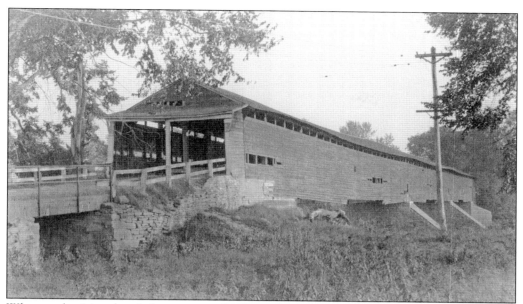

When authorities closed the gates on the Sacandaga Reservoir on March 27, 1930, the Fish House Bridge was surrounded by water in a week. It seemed to have met the test, but on April 23, 1930, heavy winds arose, and the wooden span was buffeted by waves up to six feet high. It could not withstand the storm and slid off its stone piers to settle crossways in the water. Some of the planking was later recovered and used to build two garages in the vicinity. The wooden pegs were salvaged and sold as souvenirs by the Ladies Society of Northampton Methodist Church to raise money for the church.

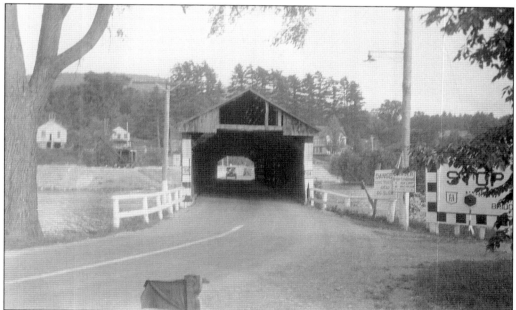

The two-span Wells Bridge was located on Route 30, north of the Sacandaga Reservoir in Hamilton County and near the village of Wells. It was built in 1866 across the East Branch of the Sacandaga River using a Town truss.

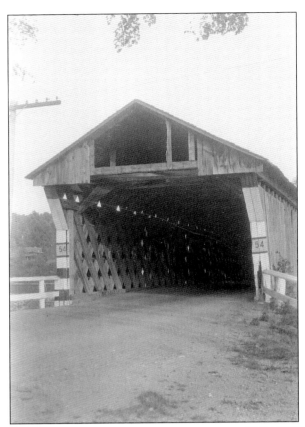

At one time, the road leading to the south end of the Wells Bridge was at the same level as the fields surrounding it, with a small hill up to the bridge. It is not known when the fill was added and the road to the bridge was raised to become level with the bridge. The Wells Bridge was originally high above the water, but the construction of the dam that created Lake Algonquin brought the water very close to the bridge. In the spring of 1930, the Wells Bridge was removed at the same time that flooding began to form the Sacandaga Reservoir. This well-built, 64-year-old span still had a camber when it was removed.

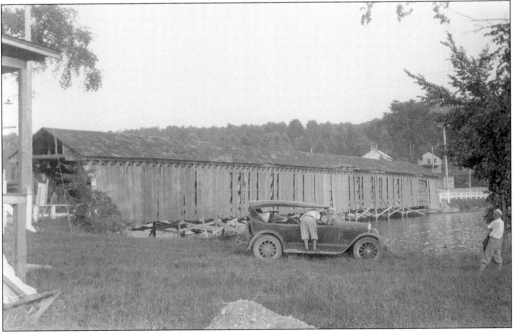

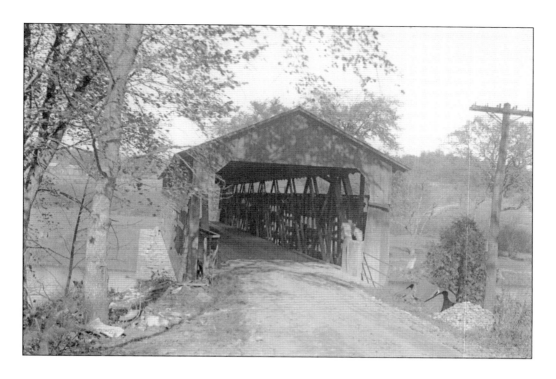

Cameron (also known as Cameron Hill) Bridge crossed between North Gage and Gravesville to connect farms of North Gage to waterpower and mills in Gravesville. It was built in 1849, when a plank road was built.

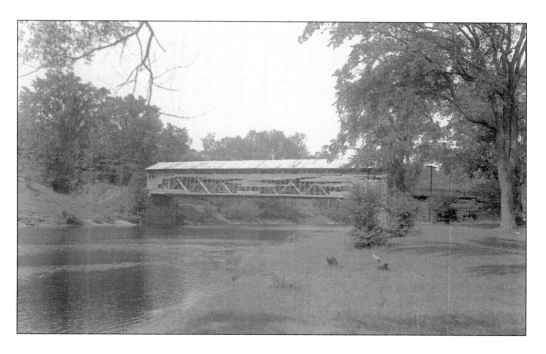

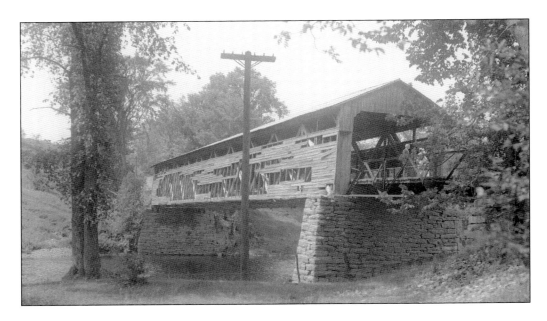

Cameron Bridge was shared between Herkimer and Oneida Counties. In its later years, this bridge only served a single farm. In 1934, the Town of Deerfield tried to buy the right-of-way, but the farm owner would not sell. In 1937, legislation was passed that would allow the county to abandon the bridge and remove it, along with the iron pony truss bridge on one end. On June 17, 1937, highway officials from Oneida and Herkimer Counties removed the Cameron Bridge. They first attempted to chop through the trusses to cause it to collapse; when that failed, they poured gasoline on it and set it on fire. The site is now abandoned.

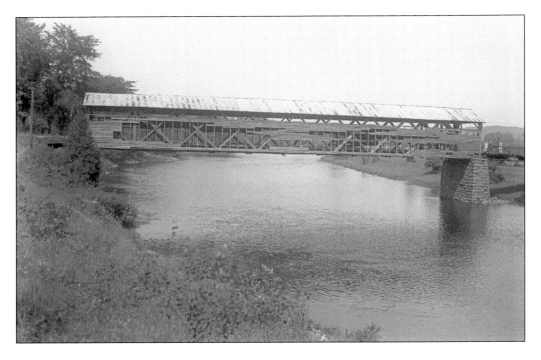

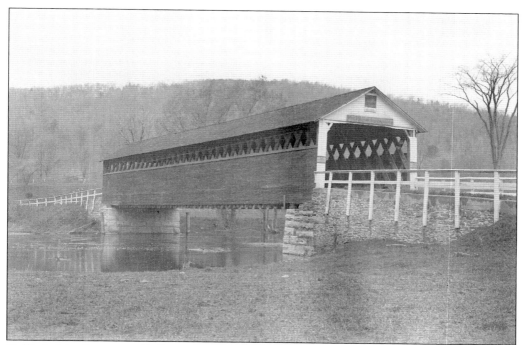

Collier's (also known as Colliersville) Bridge, located near Oneonta in Otsego County, was a landmark that stood for nearly 100 years. It was built across the Susquehanna River in 1832 on what is now Route 7. The builder of the Collier's Bridge, Capt. Edward Thorn, used 3-by-10 native hemlock timbers to fashion the Town lattice truss. The timber was turned out at Jared Goodyear's sawmill, which was located where the Collier's dam is now, and hauled to the bridge by oxen. The bridge was in constant use for 97 years and was finally removed in 1929.

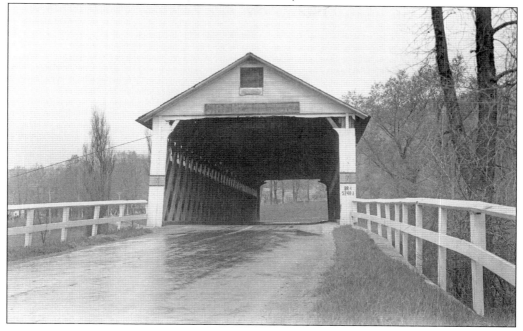

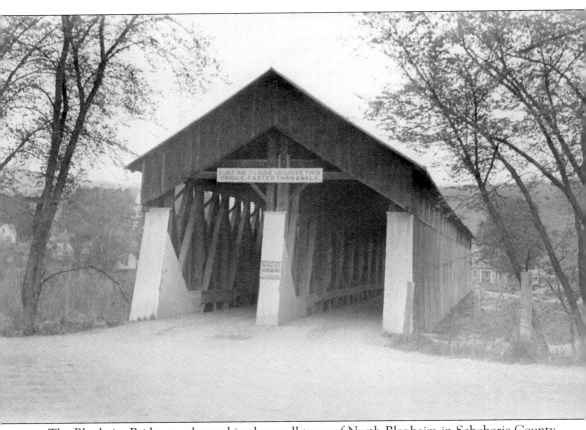

The Blenheim Bridge was located in the small town of North Blenheim in Schoharie County. Built by Nichols M. Powers in 1855, the 228-foot-long, single-span structure incorporated the Long truss design with an added arch. This truss design is rare in Northeastern covered bridges, and the bridge was still in use when this photograph was taken around the early 1940s. The sign on the bridge reads: "$5.00 fine to ride or drive this bridge faster than a walk."

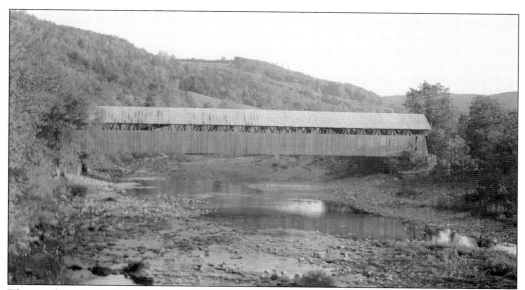

The total cost to build the Blenheim Bridge in 1855 was $6,000. This curious structure was not built over the stream as most bridges were but was constructed piece by piece in back of the village. Then, workers had to take the giant bridge apart and reerect it over the stream using temporary scaffolding set up across the river. One young man—called a "climber" because he worked high over the fast water—was killed when a heavy log fell.

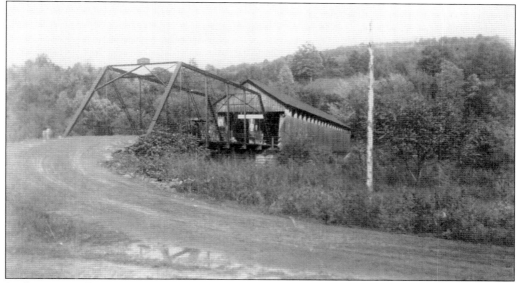

In the spring of 1869, an especially severe freshet washed out a wide channel across the western approach to the Blenheim Bridge, necessitating the erection of a small wooden extension across the gap. In 1932, a modern steel bridge replaced the wooden one, and the extension was demolished. Although builder Nichols Powers's ancient wooden structure was nearly as strong as when it was constructed and still carrying heavy loads without yielding, the iron span adjoining it cracked beneath a coating of ice. In 1930, the Blenheim Bridge was set to be abandoned the following summer after a new concrete and steel bridge was built over Schoharie Creek a short distance away from the wooden bridge. This photograph was taken August 1910.

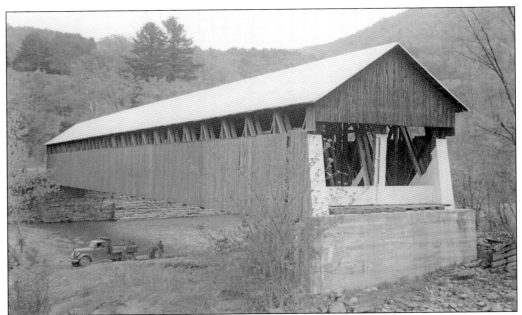

One story about the Blenheim Bridge still persists and perhaps holds some truth. It seems that workers had to hide a jug of liquid refreshment quickly one day during the construction of the bridge, so they stuck it into a niche in the unfinished abutment they were working on. Because they dared not stop working, they had to fill in the remainder of the abutment, and as far as anyone knows, the vintage 1855 jug of refreshment is still there!

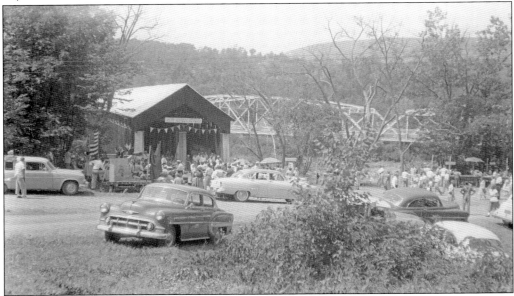

The town of North Blenheim celebrated the 100th anniversary of the Blenheim Bridge in 1955—many people attended, as shown in this photograph. On August 2, 1980, the town held another celebration, with over 3,000 people gathering to celebrate the 125th anniversary of the historic landmark. Covered bridge expert Richard S. Allen was the featured speaker at both historic events.

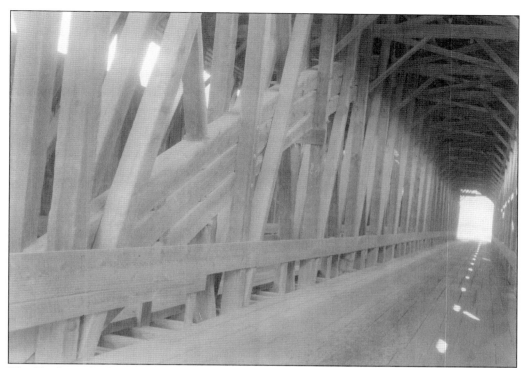

The Blenheim Bridge's main feature, the single center arch on which the bridge relied for strength, stretched in a three-rib segment from the abutments up to the ridgepole of the roof. It had three trusses: a large one enclosing the arch in the center and two side trusses, of lesser height, 27 feet apart. This divided the bridge into two lanes, sometimes called a "double barrel" or "double tunnel" bridge. The trusses were a series of wooden Xs in boxes—a system devised and patented in 1830 by Col. Stephen H. Long. The system patented by Long was used and improved upon; 25 years later, Blenheim Bridge builder Nichols Powers used bolts and washers to connect the timbers and braces. Supposedly, Powers used 3,600 pounds of bolts and 1,500 pounds of washers in the bridge's construction. The span was constructed mostly of virgin pine, with the oak arch furnished by William M. Granby, Jacob Shew, John Hager, and Peter I. Hager. An estimated 94,000 feet (127 tons) of lumber was used to build the bridge. The ridgepole was 232 feet long, the truss was 228 feet long, and the clear span was 210 feet. Powers was paid $7 per day ($2,000 total) and chose his own men; the workers received $1 per day.

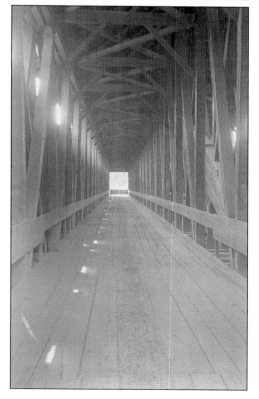

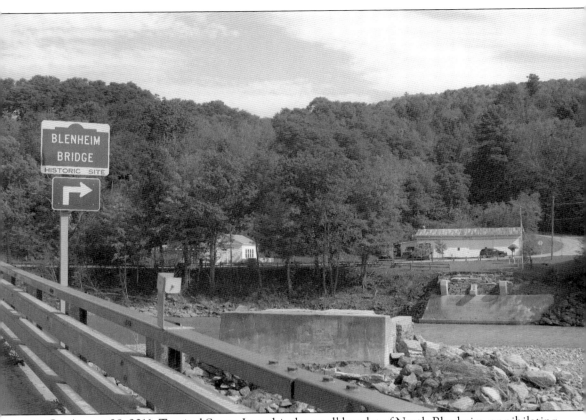

On August 28, 2011, Tropical Storm Irene hit the small hamlet of North Blenheim, annihilating almost the entire town and taking the world-famous Blenheim Bridge with it. Rising floodwaters caused by the storm lifted the bridge off its abutments and carried it downstream where it crashed against the iron bridge nearby. Today, the abutments are all that remain of the longest single-span covered bridge in the world. (Photograph by Trish Kane.)

About the Theodore Burr Covered Bridge Resource Center

Theodore Burr (1771–1882) was one of America's premier bridge engineers and designers. He is famous for designing and patenting a truss/arch combination that used a traditionally framed multiple king post truss to which a segmented timber arch was added. This is known today as the Burr truss and is one of the most widespread timber bridge designs that can still be seen in covered bridges today.

The Oxford Memorial Library is the former home of this illustrious covered bridge builder and the last known existing structure to be constructed by him. It was, therefore, the most logical location for a covered bridge resource center, and the Oxford Memorial Library included it in their capital campaign expansion and improvement project that began in 2005.

Completed during the summer of 2011, the Theodore Burr Covered Bridge Resource Center's design was kept period appropriate with the Federal-style home in which Burr lived from 1811 to 1813. The center is a modest room displaying covered bridge models and truss examples (such as queen post, king post, Howe, Town, and Burr). As part of its permanent collection, it also hosts a vast library of covered bridge–related books, magazines, and newsletters from all the covered bridge societies in existence today, as well as some that no longer exist. It also houses an extensive postcard, photograph, and slide collection dating back to the early 1950s, much of which was donated as a gift by Sherburne residents Bob and Trish Kane. Thanks to a most generous donation by Terry and Sara Miller from Kent, Ohio, the center now has several modern amenities, including computers and scanners for the convenience of the patrons visiting the center.

On July 2, 2011, the Oxford Memorial Library held a grand opening and dedication that coincided with the bicentennial of the library's construction. During this celebration, the center was officially dedicated to the late Charlotte F. Stafford, former town and village of Oxford historian, and the late Richard T. Donovan, also known as "Mr. Covered Bridge Extraordinaire."

The center is to research students, covered bridge societies, and fans of covered bridges what Cooperstown is to baseball. There is no other covered bridge center like it anywhere. The new research facility is available for serious scholars who are looking for covered bridge images (photographs, postcards, or slides), researching bridge history and details, and other documentation on covered bridges worldwide. For covered bridge fans, just being able to sit in the house that Burr built will be extra inspirational.

A great deal of work went into making the center just right, and it was made possible, in part, thanks to contributions from all over the United States and Canada. As with any library, historical society, or center, support is always needed. It is the goal of the library to have the center be totally self-sustaining. In order to do that, the center relies on the generous support of bridge enthusiasts. The center welcomes donations, which can be designated for a specific purpose or just to maintain the day-to-day operation expenses of the center.

For more information on donations or ways to support the center, contact Nancy Wilcox, library director, at ox.nancy@4CLS.org or (607) 843-6146. Covered bridge resource material may be donated to the center as long as space allows. For more information on donating resource material, contact Trish Kane, collections curator, at bobtrish68@frontiernet.net or (607) 674-9656. (These excerpts are courtesy of Woollybear Web, Oxford, New York.)

Discover Thousands of Local History Books Featuring Millions of Vintage Images

Arcadia Publishing, the leading local history publisher in the United States, is committed to making history accessible and meaningful through publishing books that celebrate and preserve the heritage of America's people and places.

Find more books like this at
www.arcadiapublishing.com

Search for your hometown history, your old stomping grounds, and even your favorite sports team.

Consistent with our mission to preserve history on a local level, this book was printed in South Carolina on American-made paper and manufactured entirely in the United States. Products carrying the accredited Forest Stewardship Council (FSC) label are printed on 100 percent FSC-certified paper.